The Gift of Sympathy
THE ART OF **MAXO VANKA**

The James A. Michener Art Museum
Bucks County, Pennsylvania

Exhibition and catalogue organized
by David Leopold

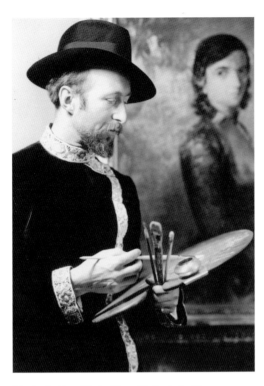

Vanka in New York City with *Lady in Blue*,
December 1934

Copyright 2001

James A. Michener Art Museum
138 S. Pine Street
Doylestown, PA 18901
(215) 340-9800
www.michenerartmuseum.org
All rights reserved.

Printed in the United States of America.

ISBN: 1-879636-13-1

Design: J. Geddis
Photography: Will Brown,
Rick Echelmeyer, Randolph Harris
Printing: Piccari Press
All photographs and text illustrations
courtesy of the Vanka Brasko Family.

Cover:
Self Portrait
Oil on canvas, 34 X 28 in., 1915
Private Collection

Dates of the Exhibition

The James A. Michener Art Museum
Doylestown, Pennsylvania

March 31 – June 24, 2001

Senator John Heinz Pittsburgh Regional
History Center
Pittsburgh, Pennsylvania

July 29, 2001 - January 20, 2002

Vanka Exhibition and Catalogue Sponsors

In Memory of Margaret Vanka Brasko
The Alexander W. Brasko Family

In Memory of Margaret Vanka Brasko
**The Frederick Rieders Family and its
Foundation**

Additional support from

The Conyne Family

Dilworth Paxson LLP

John C. and Marya Brasko Halderman

Joy C. Halderman

Morgan, Lewis & Bockius LLP

PECO Energy Company

Michael Peter and Tanya Brasko Rodich

Mieczyslaw and Elena Brasko Rozbicki

Joseph K. and Susan H. Sager

Contents

All works of art reproduced in this catalogue are by Maxo Vanka. Vanka's original titles are provided where known. For untitled works, descriptive titles are provided in brackets.

Dedication and Acknowledgments

This show is dedicated to the memory of Peggy Vanka Brasko, who gave so much of herself to make this exhibition happen.

———

When I was first asked to curate an exhibition of Maxo Vanka's work I knew little about the artist or his work. I was encouraged to come to the Michener Museum to look at the Vanka works in the collection and I was interested, but it was not until I met Peggy, Maxo's daughter, that I was hooked. She had a smile and a wink that made me realize this was going to be fun, as well as enlightening. I first learned Maxo's incredible story from Peggy in wonderfully chaotic conversations that touched on a million different subjects, each one more interesting than the last. I came to understand that with Peggy this was typical. She was a live wire, who, no matter how she felt, always made me feel better. Her passing in April 2000 robbed her family and friends of a rare individual whose love of life was contagious.

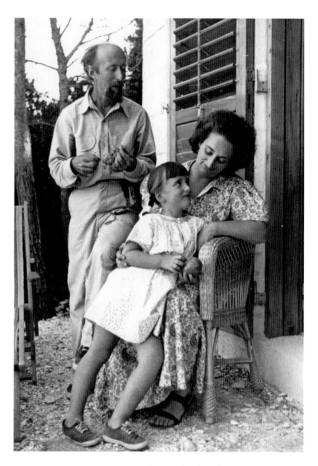

The Vanka family on the island of Korcula, c. 1938

Fortunately for all involved, Peggy married a man who, in his own quiet way, is just as life-loving and joyful. Alexander "Bill" Brasko has been a boon companion as I have navigated the thicket of Maxo's work, and his support has been invaluable in the making of this exhibition. Bill and Peggy's daughters, Tanya, Elena, and Marya, have also contributed as the various parts of this show came into focus. Marya, and her husband John Halderman, who live in the area and have worked hard to protect the natural vistas that meant so much to Maxo, have been particularly generous with their help and humor. Maxo's "gift" lives on in each of his great-grandchildren: Alex, Jan, Konrad, Maja, Marissa, and Mark. To the Brasko family I give a low bow of thanks for sharing their beautiful world with me.

I started this show with a co-curator, Judy Hayman, the former Associate Director of the Michener Museum. While she could not stay on board, her insight, intelligence, and understanding have informed every aspect of this exhibition. I am grateful to her for working with me to establish the basic framework of the show, as well as the selection of many of the works in it. It was truly at her insistence that I got involved, so I am in her debt for introducing to me this wonderful experience.

Many at the Michener have been generous with their time, input, and expertise. Director Bruce Katsiff has long held Maxo Vanka's work in high regard and he has been unstinting in his support of the project and my involvement from the beginning. Linda Milanesi first made me aware of the material and her joie de vivre has been a constant throughout the project. Carol Rossi has answered innumerable questions with grace and good humor and is simply a joy to work with. Brian Peterson was kind enough to read this catalogue and offer his insight, as well as take care of details such as paying the bills, for

which I am grateful. Carole Hurst, Amy Lent, Bryan Brems, Lynn Durgin, Zoriana Siokalo, Faith Jones, and as always, Gilbert Winner, have been quick to lend a hand or ear whenever necessary.

In understanding Maxo's work and life in Croatia, Peggy introduced me to Nikola Vizner, who was kind enough to provide an essay on the foundation of Maxo's work for this catalogue. And to Nena Komarica and Biserka Rauter Plancic, co-curators of the upcoming Vanka retrospective at the Gallery Klovicevi Dvori in Zagreb, who shared some of their research with me. And for help in understanding Maxo's murals, Peggy led me to Diane Novosel and David Demarest in Pittsburgh. Demarest, the good soul that he is, put me in touch with Randolph Harris, whose stunning photographs of the murals have introduced many to Maxo's work. In Pittsburgh I also met with Richard Domencic, who has been very generous with his research on the Millvale Murals. Peggy also provided the contact to Judith Christian, who graciously let us publish her late father's essay on one of Maxo's most unique works, the collage *World War II*.

The look of this project from paintings to printing is the result of the exceptional talents of J. Geddis, who designed this catalogue, Will Brown, who photographed almost all the works in it, and Jay Poko, who took care in printing it. A special mention should be made of Fred Koszewnik and Andrew Bertolino, who performed that alchemy known as painting conservation that has brought several important works in the show back to life. As always, my wife Laura Rathgeb's smiles, support, and sustenance have been an incredible help during this project.

Maxo's "gift of sympathy" has hovered over this project from the start. Almost everyone whom I have contacted has been extraordinarily helpful, and frequently has led me to someone else just as gracious. This, I believe, is a testament to both Maxo and Peggy. In getting to know them both over the course of my research, it is no surprise that they continue to bring people together for art and understanding.

David Leopold
January 2001

David Leopold is an independent curator who has organized exhibitions for a number of institutions including the Library of Congress, the New York Public Library, the Katonah Museum of Art, and the Norman Rockwell Museum at Stockbridge. He is the Director of the Studio of Ben Solowey in Bedminster, Pennsylvania, where he presents regular exhibitions of the work of Ben Solowey and Solowey's contemporaries.

Director's Foreword

Some artists find themselves living in two different worlds. Their personal circumstances may be secure and comfortable while their artistic interests may be directed toward the underclass and the victims of oppression. There are many examples of artists who lived in relative comfort while focusing their creative energy on examining the lives of the less fortunate. We define the artistic temperament in large part by the ability to observe and understand the human experience even when that experience is not part of the artist's personal history. Artists help us see and understand our world. Both the pleasure and the pain need to be examined if we are to maintain a balanced view of life. The American photographer Diane Arbus was born to great wealth and privilege. As a child, Arbus recalled her observations of the gritty flow of New York humanity from the isolation of her family's Fifth Avenue apartment. As an artist, Arbus focused her camera lens on social outcasts that she never encountered in the wealthy and socially prominent circles of her family. It was with a sense of respect and awe that Arbus haunted the backrooms of Times Square and the wooden benches of Washington Square Park searching for her subjects. Arbus did not give them dignity, she only revealed their dignity to a society that was often blind to the nobility of the social outcast.

Maxo Vanka, born in 1889, was raised in a peasant family until the age of eight. After this early life in poverty, he was introduced to the aristocracy by a wealthy benefactor and fully entered the world of privilege upon his marriage to Margaret Stetten in 1931. In New York his life style as the husband of Margaret Stetten created a conflict between personal comfort and his passion for observing and documenting the underclass. For most of his artistic career, Maxo mixes together his classical training and highly developed drawing skills with the anger of a reformer and the didactic narrative of a classical painter. Every social and political conflict that he observed found expression in his drawings, paintings, and frescoes. World War I, World War II, and the ever-present American racial conflict are repeated themes in his work. Even after he moves to bucolic Bucks County to concentrate on landscape painting, he travels across Asia to return home and paint his last major work of social comment: *The Leper Colony*. His youthful fire, as an observer of social injustice and human brutality, is never extinguished.

The Michener Art Museum is proud to present this first retrospective exhibition and catalogue examining the career of Maxo Vanka, a Croatian immigrant who moved to Bucks County in 1941, just one year after he had become an American citizen. This county's artistic traditions are strong and span a diverse group of artists who explore a wide range of artistic styles. Maxo is yet another artist of talent and passion whose work deserves broader recognition and attention. The work of David Leopold, an independent curator, has brought this project together with scholarship, persistence, and a strong belief that "attention must be paid" if an artist's work is to survive and find an interested audience. David was assisted in his efforts by members of the Vanka family who granted access to pictures and papers, making the research possible. The family has also donated many important pictures to the museum's permanent collection. Many other members of the museum staff also helped in realizing this exhibition, including: Judy Hayman, Carole Hurst, Carol Rossi, Zoriana Siokalo, Amy Lent, Linda Milanesi, Lynn Durgin, and Bryan Brems.

I invite our audience to feel the passion and sense the intensity that the frail and gentle Maxo Vanka expressed in his powerful works on paper and on canvas.

Bruce Katsiff
Director/CEO
James A. Michener Art Museum

Preface

"In Yugoslavia there was an intensity of feeling that was not only of immense and exhilarating force, but had an honorable origin, proceeding from realist passion, from whole belief."

Rebecca West wrote these lines in her book *Black Lamb and Grey Falcon*, a classic examination of what was then called Yugoslavia, its people, its history, and its politics. Written in 1937, her observations of the people and the land seem as accurate today as they did nearly six decades ago. Born seven years before Maxo Vanka, West first visited Croatia, Vanka's homeland, soon after he left. Nevertheless, she saw the world Vanka had inhabited, and was exposed to the ancient culture of the area that meant so much to the artist. She marveled at the Byzantine frescoes in churches, the contemporary painting, the performing arts, and the centuries-old textile designs she found in the Croatians' daily life. She recognized that it was passion that made the culture of Croatia so beautiful.

West also wrote, "There is no end to political disputation in Croatia. None." "Political disputation," to use a mild euphemism for war, is perhaps the reason many today know of Croatia. Its fight for independence in the 1990s provided a steady stream of indelible images of war. Croatia, and the states that make up the Balkans, have such a long history of conflict, that to "Balkanize" means to break up into small hostile units. The passions run deep and the memories run long. Despite the mystery of his parentage, Vanka clearly identified himself as a Croatian, and was steeped in the history, mythology, and customs of his homeland, yet this exhibition—and his work—is not about politics. Vanka did not shy away from political battles, but he used specific incidents to touch on universal themes. For example, World War I, which he saw firsthand in the Red Cross, came to represent all wars in his work. Images from that conflict became a visual shorthand for the atrocities of war, no matter when it was fought or who was fighting, just as Vanka also frequently employed the images of Christianity, not as a badge of his faith, but as symbols of human suffering and human goodness. Vanka was not a religious man, but he was spiritual. Nature was his church, with the flora and fauna his sanctuary and fellow congregants. It was his empathy for his fellowman, the "gift of sympathy" that manifested itself early in his life, that was the impetus for his greatest works.

His vibrant pictorial sense, drawn from a combination of the Old Masters and the early Moderns, flowered in numerous paintings, drawings, and sculptures. Thousands have seen Vanka's unforgettable Millvale Murals in Pittsburgh, and many more were touched through his teaching and painting in Bucks County. Yet since his death in 1963, only a fraction of his work has been exhibited in America.

The goal of *The Gift of Sympathy: The Art of Maxo Vanka* is to examine, for the first time in this country, Vanka's full body of work. It is the intent of the exhibition and this catalogue to show the evolution of this unique artist's work, while at the same time to illuminate the artist-emigré's experience in America in the first half of the twentieth century. In the following five essays, each devoted to a period of his career or to a particular work, we investigate Vanka's themes and techniques, and uncover Vanka's art, which until now has been obscured by both legend and neglect.

David Leopold
Curator

Maxo Vanka:
A Chronology

1889 October 11 Born in Zagreb, Croatia, to uncertain parentage, perhaps Austro-Hungarian nobility, Maxo was raised by Croatian peasants until the age of eight.

1897 – 1912 A benefactor moves Maxo to an aristocratic estate. Is given the last name Vanka when he begins his schooling. Enrolls at the School of Arts and Crafts in Zagreb. Studies at Zagreb Royal Academy, Zagreb Real Gymnasium and University. Learns to speak German, French, English, Hungarian, and Italian.

1914 Graduates from the Royal Academy of Beaux Arts in Brussels, Belgium, with first prize for his self-portrait and a gold medal for his work. Studies art in the Netherlands, Italy, Britain, and France.

1915 Serves as an officer in the Belgian Red Cross in World War I. His experiences in the war become a leitmotif in Vanka's socially relevant paintings. Eventually arranges to return to Croatia for the duration of the war.

1920 Becomes Professor of Painting at the Academy of Beaux Arts in Zagreb. Has annual show at the Art Pavilion in Zagreb.

1923 Vanka joins a four-week-long ethnographical expedition along the river Kupa, south of Zagreb, organized by the Ethnographical Museum in Zagreb. Vanka paints a number of village scenes and rural vistas. He collects folk fabrics that he will later use in his paintings.

1925 Wins Medailles d'Or.

1926 Decorated with Order of "Saint Sava" by Yugoslav government, Paris International Exhibition, and the Palme Academique of the French Legion of Honor.

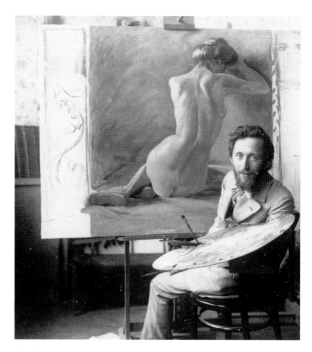

Vanka in his Zagreb studio, c. 1916

1931 Marries Margaret Stetten (1907 – 1997), the daughter of a New York surgeon. The couple lives in Zagreb and summers in Vanka's home on the island of Korcula.

1932 June 26 Birth of daughter Peggy (1932 – 2000).

1933 On Korcula, meets writer Louis Adamic. The two become close friends.

1921 – 1934 Exhibits in Brussels, Belgrade, Prague, Munich, London, Paris, Vienna, Barcelona, and Amsterdam. His work enters the permanent collections of many European institutions, such as the National Art Museum of Budapest, Prince Paul Museum of Belgrade, Strossmayer Gallery of Zagreb, and the Municipal Art Museum of Stuttgart.

1934 Vanka leaves position at Zagreb Academy, and relocates to New York City.

1934 November 26 – December 8 Exhibition at New York's Marie Sterner Galleries. Held "under the auspices of the Yugoslav government." Included in the fifteen works are *Lady in Blue, Workman,* and *Croatian Magic.*

1934 December Travels to Pittsburgh area for exhibition under auspices of Yugoslav consul. It is this exhibition that introduces Father Albert Zagar, of the St. Nicholas Croatian Catholic Church, to Vanka's work.

1935 Travels across America with Louis Adamic, mixing with immigrant workers and Native Americans, and recording American vernacular architecture, primarily skyscrapers.

1936 Louis Adamic publishes *Cradle of Life* (New York: Harper Brothers), a lightly fictionalized account of Vanka's birth and youth.

1937 March Vanka is commissioned to paint the murals at the St. Nicholas Croatian Catholic Church in Millvale, Pennsylvania, near Pittsburgh, by Rev. Zagar, where 10 percent of the present U.S. Croatian population of 500,000 reside. Works in New York on sketches for the murals.

April 9 – June 10 Returns to Millvale in April to complete eleven murals: 1) *Mary, Queen of Croatians,* 2) *Pastoral Croatia,* 3) *Croatians in Millvale,* 4) *The Crucifixion,* 5) *The Pietà, Four Evangelists;* 6-9) *St. Luke, St. John, St. Matthew, and St. Mark,* 10) *The Croatian Mother Raises Her Son for War,* 11) *The Immigrant Mother Raises Her Son for Industry.*

1938 Louis Adamic publishes *My America 1928 – 1938,* which includes a chapter, "My Friend Maxo Vanka." In April, Adamic publishes an excerpt of the profile in *Harper's* magazine detailing Vanka's work on the Millvale Murals, and the legend of the "Millvale Apparition."

Last visit to Croatia. Arranges for furniture in his homes to be shipped to America.

1939 March 13 – 27 Exhibition of thirty-five works at New York's Newhouse Galleries. Includes portrait of African-American actor Rex Ingram, recent paintings and drawings, and photographs of the St. Nicholas murals.

1939 summer Vanka's in-laws make their last trip to Korcula. They meet writer Douglas Chandler, who they learn is making pro-Nazi broadcasts in Europe. Upon their return, they contact the State Department, and Chandler is eventually convicted of treason. Inspires Vanka to create the collage *World War II.*

1940 December Vanka is naturalized as an American citizen.

1941 May Vanka and his family move to "White Bridge Farm" in Rushland, Bucks County, Pennsylvania.

July 3 – November 16 Second commission at St. Nicholas Church. Paints another eleven murals: 12) *The New Testament,* 13) *Injustice,* 14) *Justice,* 15) *The Old Testament,* 16) *Mother 1941,* 17) *Prudence,* 18-19) *Battlefield,* 20) *Croatian Family,* 21) *The Capitalist,* 22) *The Transcendent Vision.*

1947 Recruited by college president James Work to teach art appreciation classes at National Agricultural College (later Delaware Valley College) in Doylestown, Pennsylvania. He teaches there for eight years.

1950 Final trip to the St. Nicholas Church to paint Croatian folk designs on choir loft.

1955 – 1956 Takes a ten-month journey through Asia, North Africa, and Europe. Trip inspires last major works of his career.

1957 November 18 – 30 Exhibition at New York's Charles Barzansky Gallery. Vanka shows allegorical works *Four Horsemen of the Apocalypse* and *Life and Death,* along with pastels from round-the-world trip, and more conventional landscapes and still lifes.

1963 February 2 Drowns off the coast of Puerto Vallarta, Mexico.

1968 Margaret Vanka, and her stepmother Alice Stetten, give their summer homes on Korcula, and a number of Vanka's works to the Yugoslavian Academy of Arts and Sciences as a museum of Vanka's work.

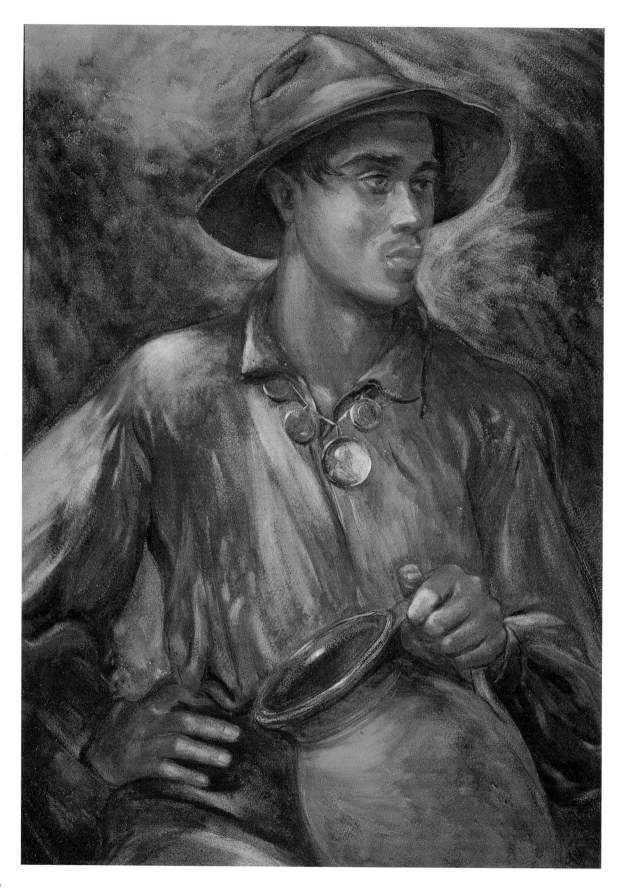

Homeland

Croatia 1916 – 1934

By Nikola Vizner

axo Vanka was born on October 11, 1889, in Zagreb, the capital of Croatia. At that time Croatia was part of the Austro-Hungarian Empire, and was closely associated with Hungary in a political union. Croatia remained a part of the Dual Monarchy until the end of World War I in 1918. After the Hapsburg Empire was dismantled, several new states were created, one being the Kingdom of Serbia, Croatia, and Slovenia. The country was renamed in 1929 and became the Kingdom of Yugoslavia. World War II brought the destruction of Yugoslavia, and a new state, the Democratic Federal Republic of Yugoslavia, was created in 1945. This state existed until the summer of 1991, when several republics proclaimed their independence, and Croatia became an independent country. The troubled history of the region influenced Vanka's youth as well as his adult life.

The story of his birth and growing up is best described in a novel by Louis Adamic, *Cradle of Life* (Harper Brothers, New York, 1936). Adamic was a Slovenian-born novelist and journalist who came to America as a teenager, and who wrote several books on the immigrant experience in the first half of the twentieth century. On a trip to Yugoslavia in 1932 to gather material for his best-selling book, *The Native's Return,* Adamic met Vanka in Zagreb and they became lifelong friends. When Vanka came to America in 1934, Adamic publicized his arrival in several newspapers, helped organize exhibitions of Vanka's work, and assisted Vanka in getting the commission for his most important American work: the murals in the church of St. Nicholas in Millvale, Pennsylvania. Adamic took the unusual story of Vanka's birth and early years in Croatia as the basis for *Cradle of Life.* This somewhat romanticized and intriguing tale is of an illegitimate child of the Austro-Hungarian nobility who immediately after his birth was given to a peasant woman, a wet-nurse, who became his mother. He lived with his adopted family in a village in Hrvatsko Zagorje, a pastoral, picturesque region north of Zagreb. Money for his upkeep came regularly to the village, so he did not share the fate of some unfortunate fachooks (a derogatory term for illegitimate children raised by wet-nurses in that region) who would mysteriously die if money stopped coming. Vanka was never certain about who his real parents were; apparently he saw his mother once as a young man, but the mystery of his origins remained with him for the rest of his life. He might have

Gypsy Boy
Watercolor on paper, 30 X 22 in.
Bucks County Intermediate
Unit #22

been the son of the emperor's son and a beautiful duchess, or the son of lower Austrian nobility from Bohemia. What is certain is that Vanka considered the peasant woman, Dora Jugova, his mother, and always had sympathy for the underprivileged, exploited, abandoned, or exiled. These characteristics are quite obvious and constant in his artwork.

After attending elementary school in the village, he was sent to continue his education in Zagreb. There he became interested in painting and joined the School of Arts and Crafts, where he studied painting under the prominent Croatian painter Bela Csikos-Sessia. Csikos-Sessia (1864–1931) was a Vienna-educated painter, a master of psychological portraiture, plein air landscapes, and historical compositions, as well as Biblical, mythological, and classical subjects. His style ranges from academic-realist tonal compositions to colorist and post-impressionistic canvases of the Vienna Secession. The Symbolist line in his work is very strong, and his paintings are often symbols of life and its manifestations: love, belief, death. In his pedagogical work as an art teacher for generations of Croatian painters, he insisted on proven methods of academic realism, giving his students traditional art school training as a basis and springboard for their future development.

Prostenjari (The Supplicants)
Oil on canvas, 1915

Csikos-Sessia had a strong influence on Vanka that can be seen in the Symbolist and Secessionist quality of his paintings well into the twenties and thirties. Vanka attended classes at the School of Arts and Crafts from 1908 to 1910, and a number of works from that period show a talented young artist with a strong affinity for painting countryside landscapes and portrait studies. Several years later, these landscapes took on national cultural and historical dimensions, with an emphasis on village customs, religious processions, church interiors, candles, altars, and baroque figurines, as well as traditional village activities in the fields and orchards. It is important to note that in the summer of 1923 Vanka joined a four-week-long ethnographical expedition along the river Kupa (some thirty miles south of Zagreb) organized by the Ethnographical Museum in Zagreb. The group, using several kayaks, traveled about seventy miles along the river between the towns of Sisak and Karlovac, and undertook to study, describe, paint, photograph, and research the rural world of the still preindustrial region that was slowly disappearing. The participants, five men and two women, collected hundreds of examples of handmade textiles, tools, folk art, and folk costumes, as well as descriptions of customs, and folk stories, village traditions, and peasant life in general. Visiting altogether thirty-four villages on both sides of river Kupa, Vanka sketched and painted a number of typical village houses, churches, water mills, bridges, and river vistas. He also collected for himself a number of examples of folk fabrics and embroidery that he would later use in many of his compositions dealing with themes of village life and its customs. He also used the folklore motifs in his stage designs and costumes for the ballet *Licitarsko Srce* (Gingerbread Heart) that was produced at the Croatian National Theatre in Zagreb.

Drop curtain for *Licitarsko Srce (Gingerbread Heart)* at the Croatian National Theatre

Although Zagreb had a dynamic cultural and artistic life, in the years leading to World War I it did not have an art academy. Some of the established painters ran private art schools in their studios, but most of the young, talented, and ambitious future artists went to different central European art centers to continue their art education. For the previous generation of Croatian painters, it was either Vienna or Budapest; for Vanka's generation the choice also included Munich, Prague, Paris, Berlin, and Venice. It is not clear why Vanka chose to go to Brussels, the only one of his generation to do so. There are some opinions that the main reason was his family's enigmatic connection to Belgian aristocracy, even royalty. In 1911 Vanka continued his studies at the Royal Academy of

[Landscape]
Tempera on paper,
21 X 29 ½ in.
Private Collection

Beaux Arts, under Professor Jean d'Elville. There he was thoroughly educated in painterly techniques, and got a solid foundation based on Flemish painting, with a good understanding of Symbolist, Impressionist, and contemporary Belgian, French, and Spanish painting. He was an excellent student, had a rich social life, moved in the highest Belgian social circles, traveled around Europe, and spent his summers in Croatia. In Zagreb he participated in several group exhibitions in 1912 and again in 1913, and had his first one-person show in 1915. In Brussels he graduated with a gold medal from the Academy. The painting that won the award was *Prostenjari (The Supplicants),* a composition depicting a group of Croatian peasants praying before an outdoor altar adorned with the icon of the Virgin. Peasants are dressed in very precisely painted folk costumes reminiscent of his Zagorje boyhood region. In the background is the Zagorje landscape with its rolling hills, vineyards, and the church spires of distant villages. The painting is much more than an ethnographic picture of country life; it suggests a deeper meaning of authentic rural religiosity as well as a unity of people, soil, and spirituality.

At the start of World War I in the summer of 1914, Belgium's Queen Elizabeth arranged for the deeply nonviolent, pacifist Vanka to be an officer with the Belgian Red Cross. Vanka went to the front, and saw firsthand the horrors of the war: the destruction, death, and suffering of fellow human beings. These scenes found their way into many of his paintings, particularly in the moving Millvale Murals.

With his social connections in Belgium, he was able to secure a visa and return to Croatia in 1915. The balance of the war years Vanka spent quietly in Zagreb and the surrounding countryside, painting landscapes, lonely churches, village scenes, and portraits. He had already established his reputation with group and solo exhibitions, and was well regarded among his peers. In 1920 he became a professor at the three-year-old Zagreb Academy of Fine Arts. He remained there until his departure for America in 1934.

Vanka's artistic oeuvre in Croatia can be divided into three distinct groups: large compositions with folkloric and religious themes; landscapes, mostly from his beloved Zagorje and the island of Korcula (where he bought a small cottage to spend summers); and portraits and self-portraits.

In his interpretation of the peasant life of Croatian villages, Vanka is unique. He depicts customs, struggles, emotions, superstitions, attitudes, and the color of the peasant world with the eye of an artist and the precision of an ethnographer. He deeply understands village life and its soul: the passive suffering and happiness which are intertwined in life. These paintings have a mystic charge. In them Vanka comprehends the deep, natural mysticism and religiosity of peasants: their strange, almost pagan rites that are closer to the atavistic paganism of the village than to Christianity. These paintings explain the world in terms of the unknown and the supernatural.

In his landscapes and seascapes of the late 1920s and 1930s, Vanka traveled a long road from the plein air paintings of his early years to the folkloric landscapes and the expressiveness of almost pure colors. It is a path going from Art Nouveau decorativeness to Symbolist messages to broad and decisive brushstrokes of color that define the limits of volume and forms. It is the daring use of color that transforms these paintings of powerful pictorial value into celebrations of life and pristine nature in a pure Expressionistic universe. In the painting *Olive Tree,* one of many done in Korcula, Vanka uses pure color, expressive lines, and an aerial perspective to bring the glaring Mediterranean sun, summer heat, and aromatic scent of wild vegetation into harmony with the sea blues fused with the greens and yellows of land. The olive tree, expressive, disturbed, dynamic, and painted in bold expressionistic gestures, blends into the peacefulness of nature as a powerful metaphor for the place of the individual in the great scheme of things.

Vanka's numerous portraits are complex in execution and reveal a perceptive and sensitive artist with a rare and keen psychological insight into his subjects. Early portraits from 1915 through the 1920s employ strong symbolic and expressive values. After the war, portraits became an important part of his artistic production, as his portraits of wealthy patrons were an important source of his income. His subjects are often complemented with a Renaissance-type background landscape, sometimes imaginary, sometimes relevant to the person being portrayed. There is a feeling of oneness, of the personal and universal, of a connection to history and to the present: modernity being rooted in native soil. The background enhances the knowledge of the person, showing the land as an integral part of the subject's world. In the best of his portraits and self-portraits he achieves a unity; person and background converge in a coherent, believable oneness.

A good example is the painting *Mayor's Wife,* in which the wife of the mayor of Petrinja is set against the background of the town and its surroundings. The figure and

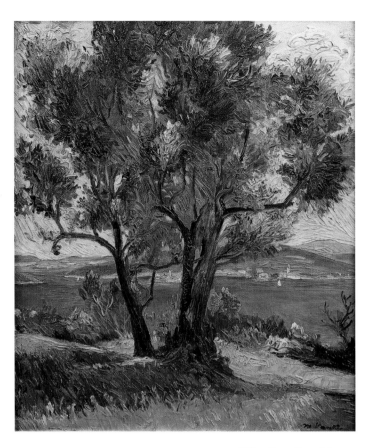

[Olive Tree, Korcula]
Oil on board, 28 X 24 in.
Private Collection

the landscape are in psychological agreement, revealing the beauty and tranquillity of both the woman and of nature. *Lady in Blue,* another portrait of the period, emphasizes the personal over nature in the background. It juxtaposes the interplay between light and shadows, flesh and fabric, in a subtle likeness of the woman's inner world that could be understood only in the context of the whole scene.

Self-portraits dating back to Vanka's student years chronicle his progress in age and art. A few are real masterpieces of the genre and Croatian art: thoughtful, balanced, and psychologically refined, they follow his artistic development, his vision of himself, and his place in the world. The paintings talk about his symbols and ghosts, and frequently show him against the landscape of his native land — sometimes the idealized landscape of his childhood. This dichotomy reveals the artist divided between past and present, one part firmly planted in the present, the other part in love with the past.

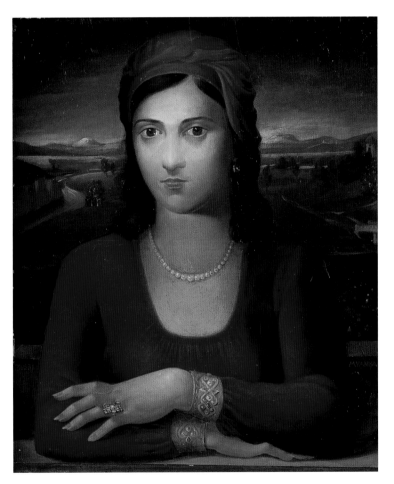

[Mayor's Wife]
Oil on masonite panel,
24 ½ X 20 ½ in.
Private Collection

In Croatian art history Vanka is remembered as one of the first painters to bring the Expressionist style in landscape painting to Croatia (G. Gamulin, *Croatian Painting of the 20th Century*, Naprijed, Zagreb, 1997). He is also remembered because he disappeared from the Croatian art scene in 1934 and was considered "lost" to Croatian art. Before he left Croatia for the United States Vanka had a large one-person exhibition in Zagreb, his farewell to his homeland. Critics lamented his decision and lavishly praised the show at the prestigious Exhibition Pavilion.

Vanka's decision to come permanently to America was a complex one: It was a mixture of personal, professional, and political circumstances. His wife, Margaret, wanted to go back to her native New York, never having adapted to life in Zagreb. Vanka had some personal and financial difficulties at the Academy of Beaux Arts, where he was a professor. And the political situation in Europe was worsening. He felt that a new beginning in America, in the New York art scene, would enhance and energize his art and his career. Although many of his friends and some art critics in Zagreb disapproved of his decision and warned him that he would be "lost" in America, he was determined to undertake the challenge of the New World and was ready to try to make his mark in it.

Work that ensued — masterful drawings of the New York urban scene, murals in the Millvale church, and oils of later years — are all testimony that his instinct was right, and that his contribution to the artistic life of his adopted country is formidable.

Nikola Vizner is an art historian with extensive experience in 20th century European and American art. Originally from the former Yugoslavia, Vizner teaches art history at New York's Touro College. He lives in New York City.

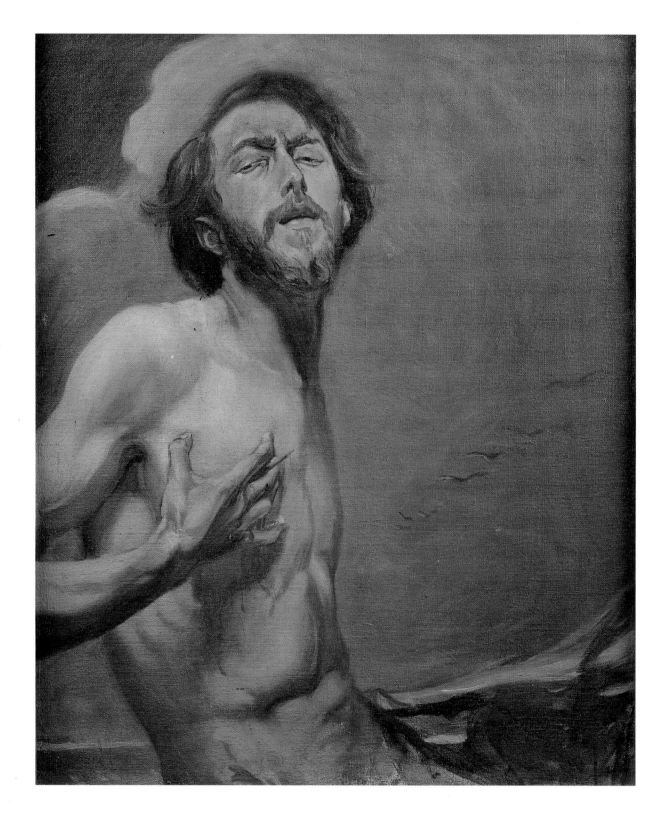

Self Portrait
Oil on canvas, 34 X 28 in., 1915
Private Collection

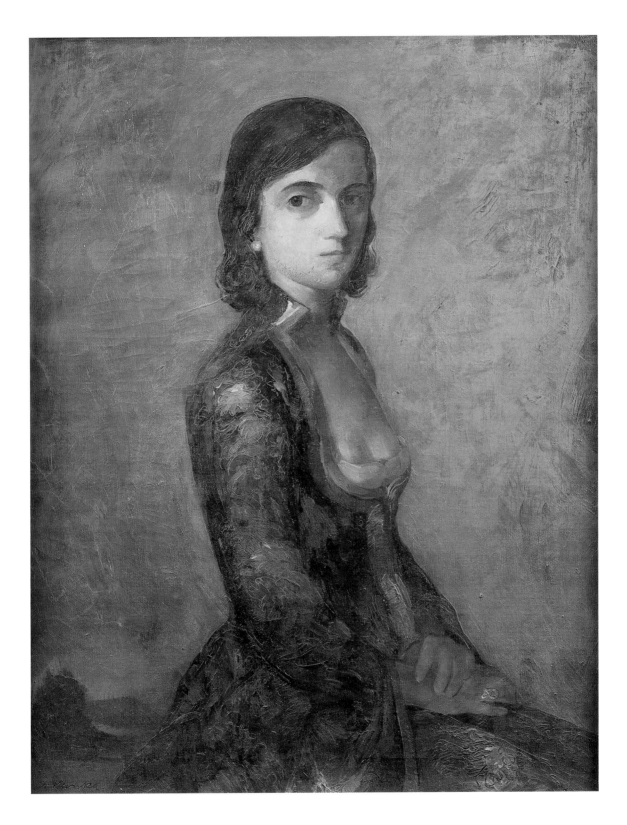

Lady In Blue
Oil on canvas, 34 X 27 in.
Private Collection

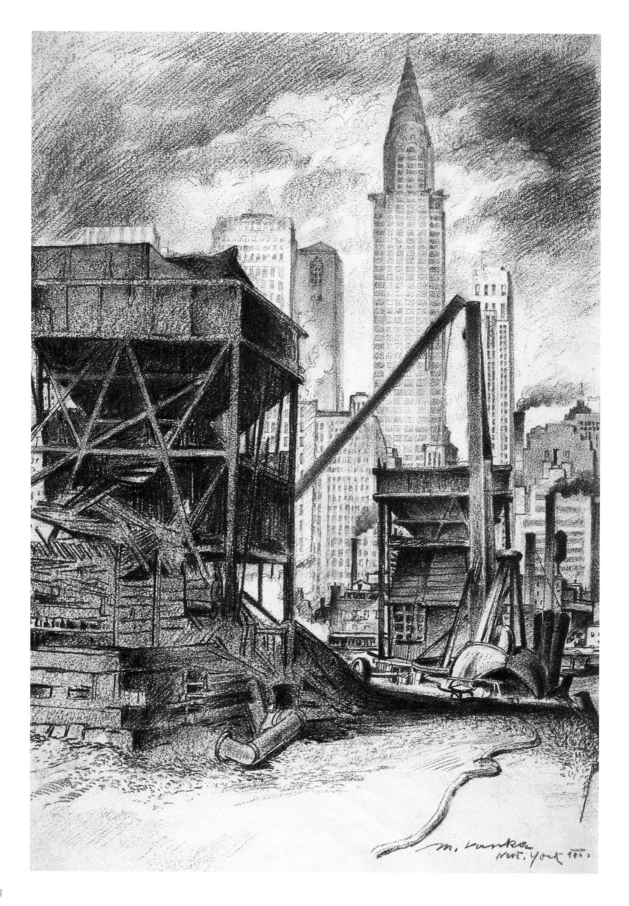

m. Lanka
New York 1930

 Louis Adamic, 1938

 Ivan Mestrovic to Vanka, 1949

A New Beginning

New York and Travels in America 1934–1941
By David Leopold

In Croatia Maxo Vanka was an artist caught in the revolving door of admiration for classical art and the lure of the Modern. His portraits drew upon a Renaissance-flavored style that turned his sitters into monuments. Yet they were composed in the rough brush-strokes of Modernism. He was considered to be among the country's best portraitists and was a well-respected teacher. Yet as in his youth, when he was torn out of a culture that he loved and put into a newer, more respected, and certainly more comfortable one, Vanka left Croatia with his family in 1934 to come to New York to begin a new life.

Three years earlier he had married Margaret Stetten, daughter of DeWitt Stetten, chief of surgery at Lenox Hill Hospital in Manhattan. In the summer of 1931, while Margaret was traveling in Europe, she experienced car trouble outside of Zagreb. Stopping at a nearby château, she found that Vanka, whom she had first met in 1926, was a houseguest. After he had sketched her portrait and after she had seen Vanka's work in the home, Margaret decided she would marry this artist. She gave up the dream of becoming an artist herself and settled on marrying one, preferably one who was poor and unrecognized, so that she could contribute to his greatness.

After studying Vanka's work in museums across Europe, she sent him a telegram some weeks later announcing her intention. Vanka at first was amused. He was living an ascetic life, and had never thought of marrying. Yet when she arrived it was clear that she was not joking. Initially he hid from Margaret, but soon he succumbed to her charms. In many ways she was his opposite. She was a vivacious earth mother with a direct manner and goal-oriented purposefulness, while Vanka was a bony aesthete nicknamed "Inri" by his classmates because of his resemblance to Jesus — in both looks and manner. His interests veered toward philosophy and mysticism. Yet their styles and temperaments complemented each other and they were married the same year. In 1932 the birth of their daughter Margaret, or Peggy, as she was called, completed the family. [3]

The family lived in Zagreb and in the summers they enjoyed Vanka's summer home on the island of Korcula. There they met Louis Adamic, during the writer's year-long residence in Yugoslavia on a Guggenheim Fellowship to research his book *The Native's Return*. Margaret enlisted Adamic's assistance in persuading her husband to leave

Margaret Stetten Vanka, 1930

[Construction Site New York]
Conté crayon, 21 X 14 ⅜ in., 1934
James A. Michener Art Museum
Gift Of Margaret Vanka Brasko

19

Croatia and live in Paris or New York, where his work could get the recognition she felt it deserved. Vanka wished to stay in his native Zagreb, where he felt connected to the land and its people, and in part because his pride refused to let him live off his wife's money.

By the winter of 1933, Adamic and Vanka had become great friends. In line to see Charlie Chaplin's film *City Lights,* Adamic remarked that the Nazis, who had risen to power in Germany and were threatening all of Europe, "had no interest in honest writing, good art, or their own respective spouses, both of whom were Jewish."[4] Vanka realized then that he could not keep his wife and daughter in the path of an ever-expanding war.

Some months later, Vanka made the decision to leave Croatia. He hoped that his future lay in New York, which was fast becoming the cultural capital of the world. Upon arriving in America, he was awed by its sheer technological progress. In a series of drawings from New York and from his cross-country travels with Louis Adamic, he repeatedly concentrated on the architectural marvels of this New World. Vanka found an idealized perfection in the relentless building in America, similar to the work of such American artists as Louis Lozowick and Charles Sheeler. In New York he was drawn to the city's skyline and its never-ending construction. In drawings such as *Construction Site New York* he captured the destruction of the old to make way for the new, perhaps as a metaphor for his own situation. In Pittsburgh, he drew a series of heroic portraits of the University of Pittsburgh's newly built Cathedral of Learning, a Gothic skyscraper devoted to higher learning. Throughout his travels in America, he continually captured American vernacular architecture.

Vanka arrived during the Depression, and may have soon realized that the façade of progress that came from building and industry was collapsing. Just as in Croatia, where he frequently drew and painted peasants and laborers, he turned to "the people" as the fundamental source of strength. Adamic wished to show Vanka that America was not all like Manhattan, and the artist joined him on several trips in the Northeast and to the Midwest. As Adamic took care of his business, Vanka would frequently check into a cheap hotel and wander the cities to sketch and meet Americans. Always he found people to draw who were on the margins of society, or, as Adamic wrote, "He seemed inevitably to gravitate toward the lowly, dirty, degenerate and neglected."[5] On a trip to California with his family in 1935, Vanka was approached by a man who recognized his sensitivity to others. The stranger proposed that Vanka found a new religion, because he "had the personality for a religious leader."[6]

In a profile of Vanka for his book *My America,* Adamic told of Vanka's "gift of sympathy," the essence of which he could not define. Adamic wrote that Vanka "was perhaps the most intensely conscious and observant person I have ever known. Nothing escaped him."[7] This "gift" caused both animals and people to be attracted to and feel comfortable with Vanka. He felt a kinship with St. Francis of

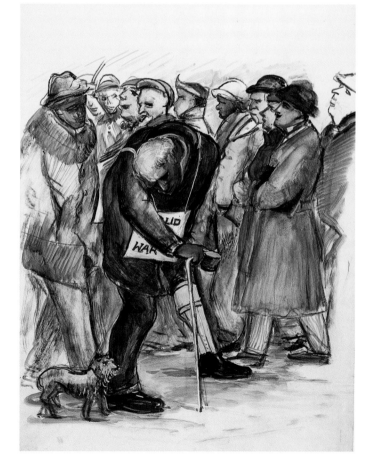

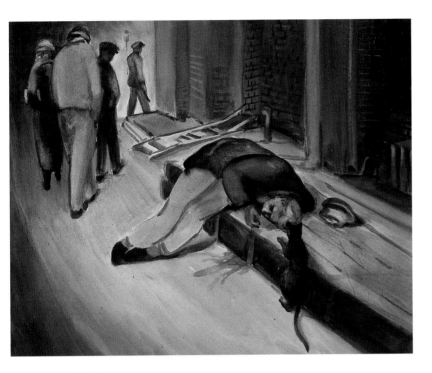

[Unconscious Man]
Watercolor, 12 ½ X 14 ¾ in.,
c. 1934 – 41
Private Collection

Assisi, the patron saint of animals, and there are many stories of birds and other animals that would alight on his head, feed out of his pockets, even "play dead" on command for him. Perhaps because of his Christlike appearance, strangers felt compelled to touch him and perhaps confide in him. His peasant upbringing gave him an understanding of poverty, and the mystery surrounding his paternity left him with a desire to please, and an awareness of human fragility.

While he lived in a thirteenth-floor penthouse on Riverside Drive, Vanka's studio was in the loft of a building owned by the Stettens in the warehouse section off the Bowery. In this neighborhood he found his subjects by occasionally donning old clothes and exploring vacant lots, deserted buildings, and the underbelly of the city's bridges. The homeless, African-American laborers, and prostitutes were frequent subjects of his work. He was an artist of the immediate, setting down what he encountered in the streets and alleys. The Farm Security Administration photographers, like Vanka a decade earlier in Croatia, had begun to make ethnographic expeditions into America's heartland to discover, or perhaps recover, some lost truth or understanding of the human condition. Likewise, Vanka's depictions of the inequities of the less fortunate alongside his drawings of towering edifices compelled viewers to confront the dichotomy between America's ideals and its realities. In some works, such as *Crippled War Veteran,* Vanka captures the dichotomy in a single work, as well-fed people stroll down the street oblivious to the anguish of the veteran who asks for a handout. In the watercolor *Unconscious Man,* not even the policeman seen in the background helps a man who has collapsed on the street. Only a black cat stops to investigate. Adamic wrote, "His impression was that deep in them, many Americans were unhappy people, hungry for something...he wished, laughing, he really were Jesus and able to perform in America the miracle of loaves and fishes on the spiritual and cultural plane."[8]

Vanka chose to explore the everyday reality of the present in his work in America. Like the painters of "the 14th Street School" led by Kenneth Hayes Miller, Vanka took the order and simplicity of the classical art he was rooted in as the model for his work on vernacular subjects. He stressed more formal qualities in his depictions of urban life, taking his compositional cues from Renaissance art, and his drawings of the homeless and less fortunate bestow a dignity upon these subjects, transforming them from outcasts to icons. One imagines Vanka alluding to the Madonna and Child against the backdrop of the city in his *Rooftops* watercolor. Or the recumbent image of Jesus of the Pietà in his drawing of a sleeping man. And while the 14th Street School erased all references to poverty and ethnicity, Vanka exposed in his works the fundamental tear in the fabric of American society.

Vanka discovered the parallels in urban street life to his impoverished upbringing.

[Crippled War Veteran]
Watercolor and ink, 18 X 12 in.,
c. 1934 – 41
Private Collection

"These people seem to him," said a *Newsweek* review of a 1939 exhibition at New York's Newhouse Galleries, "the American counterpart of the simple peasants he loved to paint in his native Zagreb." [9] He could have easily produced portraits of the rich and the powerful in New York, primarily through the Stettens and much as he had done in Zagreb. But he found himself continually returning to the Bowery or to Harlem, which he had been introduced to by the actor Rex Ingram, for his subjects. His work of city life abounds with the vitality of the urban culture of the time. And while many artists were captivated by the nightlife of Harlem, Vanka intuitively understood, and wished to record, the everyday life and struggles of African-Americans. In these works, Vanka is an observer rather than a critic, capturing a stolen moment in their lives — such as the drawing of the *Dice Players,* for instance, a spiritual cousin to Cézanne's *Card Players,* or in the wash drawing *Figures Warming By Fire* — as an inevitable part of life.

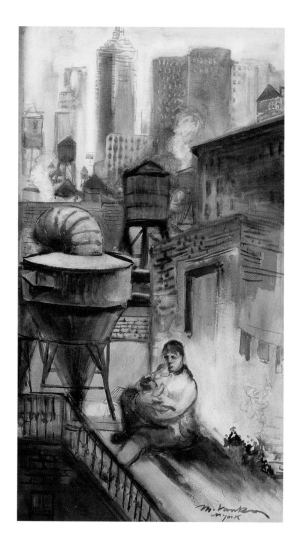

At the opening of the Newhouse Galleries show the *Newsweek* review continues: "His humble friends had all the positions of honor; the most impressive works were a canvas of bums sleeping in a deserted subway station[10] and drawings of steelworkers and miners." [11] In his catalogue appreciation, critic Alfred Frankfurter wrote that these works of "certain strata of American life...spring out of the irreducible combination of passionate sympathy, keen wit and absolutely pictorial phraseology which is to be found in Brueghel, in Callot, in Goya, in Daumier, and, alone among living artists, in Rouault." [12] In an exhibition of thirty-five works and photographs of the Millvale Murals, Frankfurter also singled out the monochromatic nature of many of the works for praise, comparing their vividness to "early Flemish grisaille" and the "single tonality in Goya's aquatints." [13] Despite the accolades, Vanka sold few works.

Vanka also experimented with social commentary in his work outside of its full flowering in the Millvale Murals. In the 1935 work *No More War!* he showed the broad avenues of an urban landscape clogged with a parade of people holding grave marker crosses and banners that read "Down with War and Fascism" and "No More War!" Standing among the marchers is a reasonable facsimile of the Capitalist who would appear in the Millvale Murals six years later, clutching a bag of money with arm outstretched as if to demand more, and Death with his chalice pointing to figures in the crowd. Framed by flags of many nations, a mother and children weep over a float made to resemble a graveyard or a coffin. For Vanka, greed and death had conspired to foment another war to engulf the world.

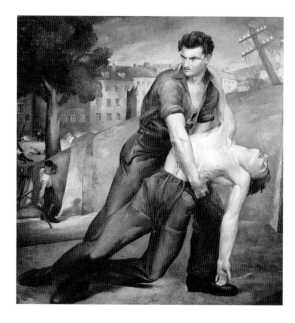

Vanka's social conscience was not a new phenomenon upon his arrival in America. In Croatia, his conscience, probably informed by Christian socialism, was the impetus behind two significant canvases. *Wounded Friend* shows a man struggling to help his comrade who has been hurt, against the background of an industrial cityscape. Are they

Left, [Rooftops]
Watercolor on paper,
21 X 12 ½ in., c. 1934 – 41
Private Collection

Below, Dice Players
Wash drawing sepia, 20 ½ X 16 in.,
c. 1934 – 41
James A. Michener Art Museum
Gift Of Margaret Vanka Brasko

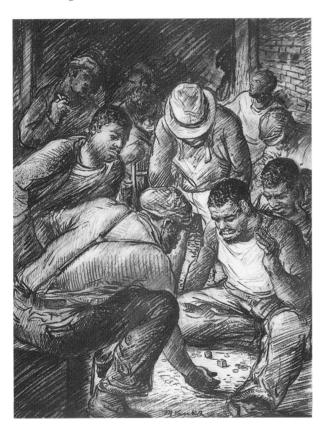

Left, Wounded Friend
Oil on canvas

reacting to an attacking foreign enemy, or to their own army or police? Has the wounded man been shot, has he been beaten, or is he simply starving? Balkan history is so rife with possibilities, and with the exact date of the work unknown it is perhaps impossible to know exactly what situation Vanka is commenting on; but as always, man's relationship to his fellowman is at the heart of the work.

Perhaps the most significant socially relevant work to survive the journey from Croatia is Vanka's early masterpiece simply titled *Nase Majke 1914 – 1918 (Our Mother 1914 – 1918)*. The composition shows a group of Croatian women in full native dress, mourning at the coffin of a dead soldier. This commentary on the senseless deaths in World War I, which Vanka saw in person in the Belgian Red Cross in the early days of the war, was only slightly reworked to fill a wall of the St. Nicholas Church. In terms of composition, *Nase Majke* fits in with the celebrated large ethnographic canvases Vanka painted for public spaces in Zagreb. Unlike those works, although allegorical in perhaps ways that only audiences familiar with Croatian culture may understand, this work provides a direct reference to the current events of the period. Painted immediately after the war, Vanka's intended audience would have instantly understood whom the women represent, with the caption as a poignant and somewhat ironic reference to the land and religion.

In a newspaper interview twenty-three years later, Vanka told of the incident that inspired the canvas. "As the Mother of God gave her Son for humanity, so this mother gave her son for her country. This was a boy — a beautiful lad — who was shot in the head on the Italian front. In the midst of a terrible tempest, he got out of the base hospital. Seeking his mother, he walked fifteen miles through the storm. He was found in the morning at the base of the little hill where his village was situated. He was so emaciated as to be unrecognizable, and all the mothers came, crying 'It's my son; my son!' But then they saw he had only one arm; and there was a birthmark by which he was identified. I have painted his mother weeping for him, with the little graveyard in the background."[14]

That he chose to bring this work to America, and eventually incorporate it into what may be his greatest work, is a testament to the composition's importance. Yet, as in much of Vanka's oeuvre, there is a paradox. Despite the work's significance both to his work in Croatia and his accomplishments in America, in the late 1950s Vanka chose this canvas as the only one he would reuse in his career, as far as it is known. After traveling around the world for ten months in 1955, Vanka returned to create the last monumental canvases of his career. He restretched the canvas and on the verso painted an allegorical rendering of a leper colony he had visited in his travels. Not surprisingly, both works deal with suffering, yet *Nase Majke* deals with the suffering of a nation as well as an individual, while *The Leper Colony*, utilizing a similar metaphor of mothers, addresses the plight of a small group. The events of the intervening thirty-five years may have changed Vanka's outlook on humanity, but not his sympathy. That sympathy was given full rein when Vanka received a message from a priest of a homely church located in Millvale, Pennsylvania, right across the river from Pittsburgh.

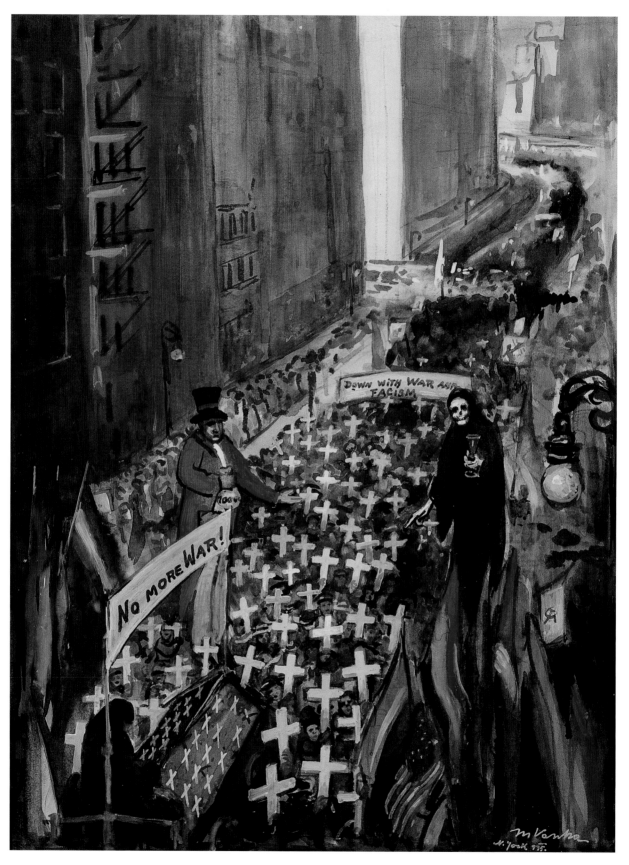

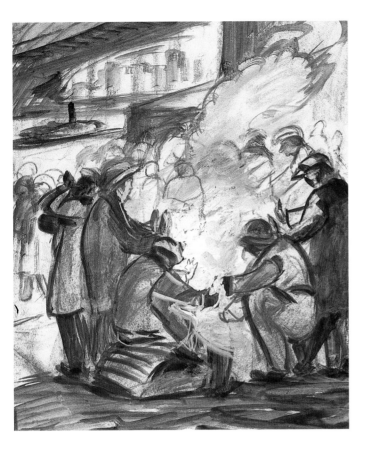

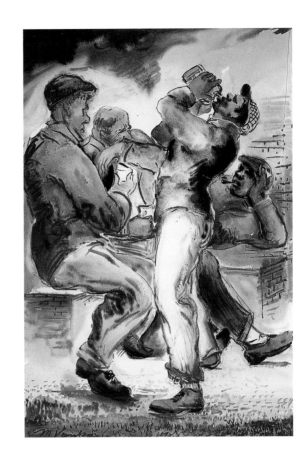

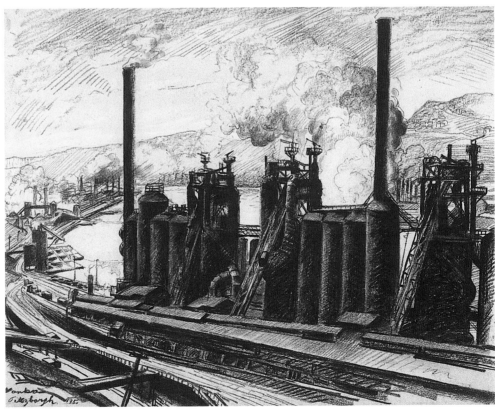

Above left,
[Figures Warming By Fire]
Conté crayon on paper,
11 ⅞ X 9 in., c. 1934 – 41
James A. Michener Art Museum
Gift Of Margaret Vanka Brasko

Above right,
[Four Men Drinking]
Watercolor on paper,
 20 ½ X 14 in., c. 1934 – 41
James A. Michener Art Museum
Gift Of Margaret Vanka Brasko

Right, *[Factories Pittsburgh]*
Conté crayon,
15 ⅞ X 21 ⅜ in., 1935
James A. Michener Art Museum
Gift Of Margaret Vanka Brasko

Left, *[No More War!]*
Watercolor,
13 ¼ X 10 in., 1935
Private Collection

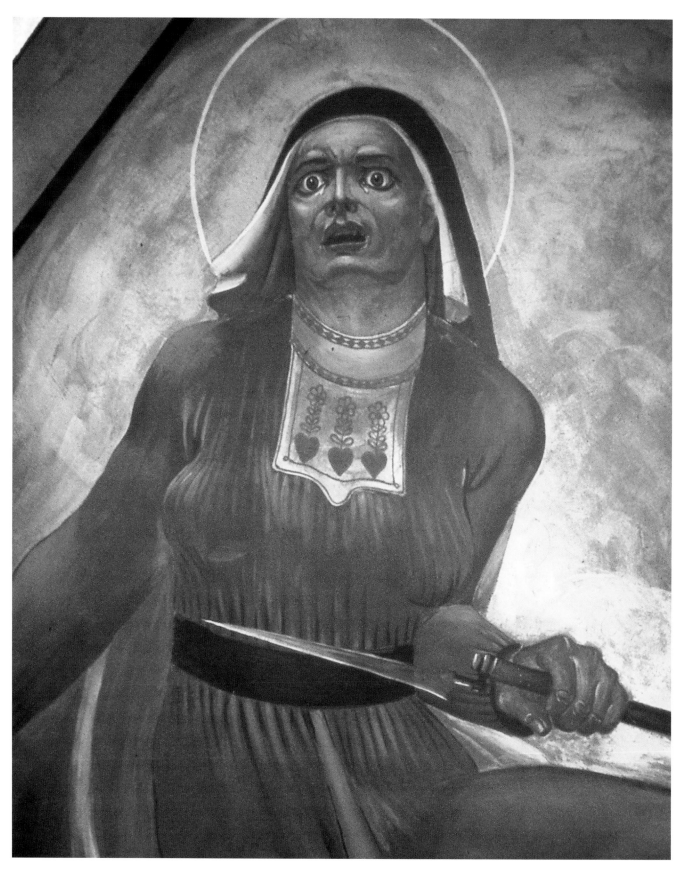

"I want to show my gratification to this country. Every man who comes to America from the European cemetery should show his gratification to his adopted land by making a contribution to its culture. This church will be mine." [15]
> Maxo Vanka

"We wanted to beautify the church. We wanted murals that would tell the story of this parish, of the people." [16]
> Father Albert Zagar

Pictures of Modern Social Significance

The Millvale Murals 1937 – 1941
By David Leopold

By early 1937, Maxo Vanka was at a low point. The activity in America energized him; nevertheless, commercial success and proper public recognition eluded him. He had several well-received shows in New York and one in Pittsburgh, exhibitions that had garnered praise from *Time, Newsweek,* and *The New York Times,* but still he did not feel he had a place in the American art world. He considered several of his recent works to be among his finest, yet sales of his works were few. He felt dishonest living off the abundant wealth of his wife and her family, and considered opening an art school. Fate intervened when Louis Adamic delivered a letter from Father Albert Zagar, the pastor of the Croatian Catholic Church of St. Nicholas in Millvale, Pennsylvania. Zagar had written Adamic to see if he knew how to reach Vanka, whose work he had seen in Vanka's solo exhibition in Pittsburgh in December 1934. Zagar had recently taken over the church, and after erasing its debts had decided to enhance the homely church's interiors with murals. "When I heard of Maxo Vanka the artist — one of our people, a Croatian living in New York — I immediately sent him a wire: 'Come Friday! Come Sunday!' And he came right away." [17] Vanka did go to Millvale, which lay right outside of Pittsburgh, and was impressed by Zagar as smart, simple, direct, and as Adamic remembered Vanka's reaction, a "true follower of Saint Francis of Assisi." Vanka also was reassured that he would have complete artistic freedom, "so long as, at least, some of the pictures were to be of a religious character." [18]

Traditionally, Croatians used religious beliefs and their church as a connection to their native land and as a way of adapting to their new one. Croatian Catholicism in particular has a history of intermingling religious and nationalist ideas. And in America, while the surrounding cityscape was constantly mutating outside of the immigrants' control, the church interior was one space they did have control over. Vanka realized that even though the church's exterior was nondescript, the interior was ideal for murals. He left specific instructions for the walls' preparation and then returned to New York, where he busied himself with sketches for the murals. He returned in early April 1937 to Millvale, where he virtually singlehandedly created the set of eleven murals in an intense eight-week stint that would encompass religion, Croatian life both in the Old and New

Detail of *Battlefield (Holy Mother)*
Mural for the St. Nicholas Croatian Catholic Church
Egg tempera on plaster, 1937

Worlds, the labor movement, and war. In 1937, America was enjoying a renaissance of mural painting. The American government, as a way to both employ artists and to promote the social ideals of the Roosevelt administration, sponsored a number of murals to embellish public buildings. As a result, many artists felt they should go beyond aestheticism and address the social and political issues of the day, and worked to create a national art that would articulate the life, history, values, and achievements of the country. The government murals shared with Vanka's work a simple goal: to make their viewers "feel comfortable about America." [19]

The ever-quickening pace of American progress, alongside the poverty of the Depression, probably also explain why Vanka, like his contemporaries the American Regionalists, turned to a "usable past" as a way to rekindle faith in the congregation of St. Nicholas. By providing soothing images of Mother Croatia and various saints and holy men, as well as idealized pastoral settings in Croatia and Millvale, Vanka was drawing parallels between the past and the present. In this way, he sought to reassure the Croats in this hardscrabble community that history shows the strength of the ideals of community and hard work.

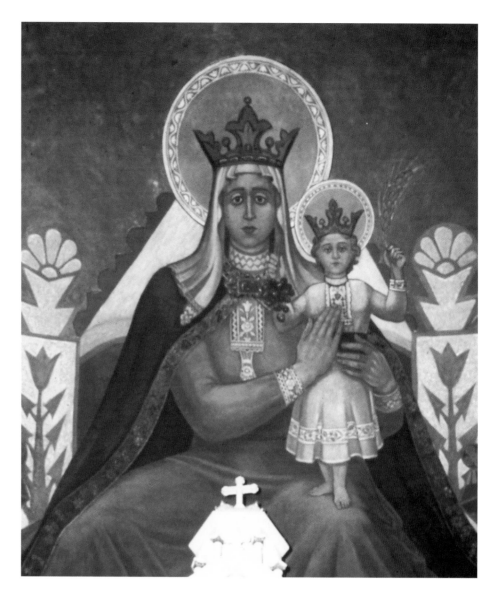

Byzantine church frescoes date back to the eleventh century in Croatia. Where Roman and Renaissance art sought to re-create reality, Byzantine art conveyed holiness as a spiritualized and visionary attitude. Byzantine artists tried to "penetrate the infinite." [20] The artists attempted to show the inner being of saints and celestial beings as well as showing more traditional symbols such as halos and wings. By using the shared vocabulary of religious iconography that his countrymen were familiar with, Vanka created a visual analogue to the Byzantine frescoes of their homeland.

Behind the church's large main altar, Vanka painted an image of Croatian life in both the Old and New Worlds. To the left is a scene that could have come from his earlier ethnographic paintings from Zagreb. It shows a Croatian family in native dress praying in a pastoral Croatian landscape. It is not surprising that, with the limited time Vanka

Left,
Detail of *Mary, Queen of Croatia*
Mural for the St. Nicholas Croatian
Catholic Church
Egg tempera on plaster, 1937

Below left, Vanka appears tiny next
to the thirty-six-foot tall mural
Mary, Queen of Croatians, 1937

Below,
*The Croatian Mother Raises Her
Son for War*
Mural for the St. Nicholas Croatian
Catholic Church
Egg tempera on plaster, 1937

had for preparation and in painting the murals, he borrowed figural compositions from earlier works, including *Proljenti Blagoslov,* for this image. Directly across from this scene is one of immigrants in America in their work clothes, holding picks, shovels, a lunchbox, and a replica of the St. Nicholas Church. Father Zagar, in one of the few portraits in murals, kneels in supplication before them, against an industrial landscape of Western Pennsylvania. The scenes are connected by an image hidden by the altar of a ship sailing across the ocean.

All eyes peer toward the ceiling where Vanka painted in Byzantine tradition a thirty-six-foot tall Madonna and Child, captioned "Mary, Queen of Croatians, Pray For Us," the image of a simple woman and child seated on a throne dressed in traditional Croatian finery. "This is no fragile Madonna. Vanka's enthroned Mother of God is a peasant woman," writes historian Francis Babic. "Look at her hands. These are a peasant woman's hands, hands which know the labor of the fields." Babic points out that by dressing a peasant woman in regal clothes, Vanka made the connection between the Virgin Mary and the woman who raised him, as well as the women of the Millvale community, "bestowing dignity and worth upon these women and their lives." [21] The image of the Mother is reinforced throughout this set of murals. To the right and left of the church's main altar, Vanka painted scenes of the Crucifixion (for which he used an African-American mill worker as a model),[22] emphasizing the weeping mother, and the Pietà, with Mary surrounded by the seven daggers of her sorrows, weeping over her dead son.

Directly across from these images, on the back walls of the church, Vanka replayed the scenes in a contemporary context. In one of his best-known murals, *The Croatian Mother Raises Her Son for War,* Vanka echoed the weeping mother of the Crucifixion and

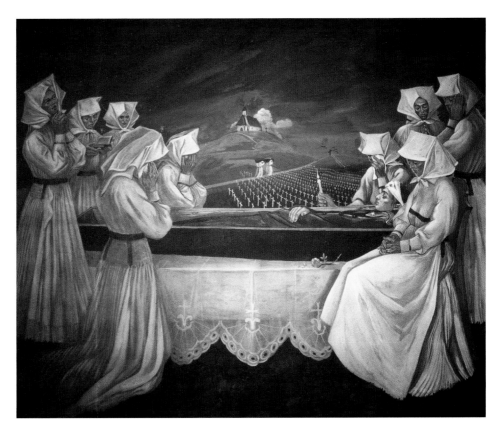

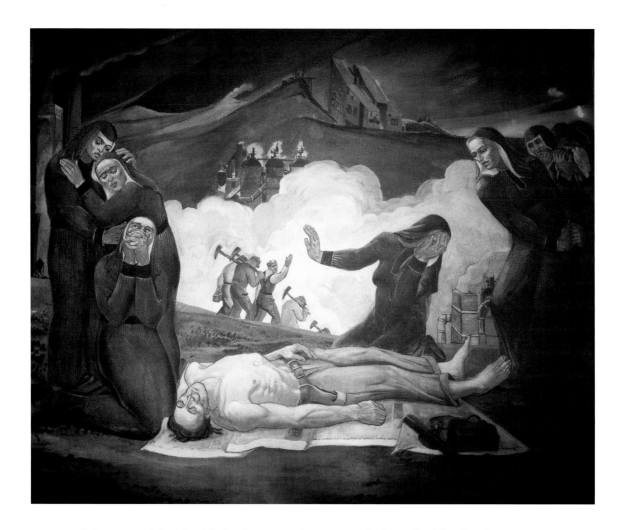

re-created the image of the *Nase Majke,* elongating the image to fit the wall of the church. On the other back wall, Vanka reprised the image of the Pietà for *The Immigrant Mother Raises Her Son For Industry*. In this mural, workers go down to a coal mine while a mother weeps over her dead son lying on a newspaper that says in Croatian, "The immigrant mothers have sacrificed their children for building American industry." [23] Like the Croatian Mother mural, this scene is also based on an actual incident. According to Vanka, the image "comes from a disaster near Johnstown where seventy-two men were trapped in an explosion. The body of this son was the first brought to the surface. The mother is sorrowing over him while at the same time sending his three brothers into the mine with a rescue expedition. It actually happened that she lost all four sons." [24] He had spent time in Johnstown in 1935 and 1937, living among the miners and sketching scenes in and around the mines, and no doubt had heard firsthand accounts of the disaster.

Vanka was a social activist, a Croatian Diego Rivera if you will, who infused his work with a sense of urgency, and sought, through his painting, to idealize and advance the interests of the common man.[25] Unlike many of his American contemporaries in the WPA, Vanka not only portrayed an idealized vision of the past and present; he included a disturbing picture of present-day realities to compare with his more poetic and religious iconography. Into this milieu, Vanka's already considerable knowledge of the fresco tra-

Below, one of Vanka's humorously illustrated letters to his family regarding his work on the murals, 1937

Left,
*The Immigrant Mother Raises Her
Son for Industry*
Mural for the St. Nicholas Croatian
Catholic Church
Egg tempera on plaster, 1937

Below, *Mati 1941*
Mural for the St. Nicholas Croatian
Catholic Church
Egg tempera on plaster, 1941

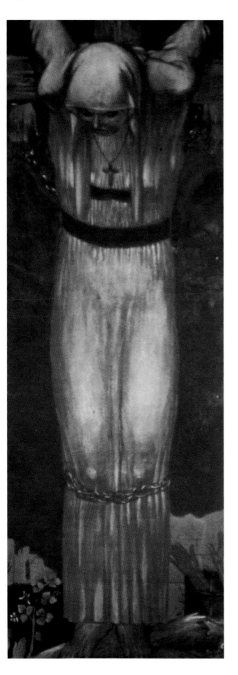

dition in Croatia fused with the emerging ideal of cultural nationalism. Vanka mixed Old Master techniques, descriptive details, decorative patterns, and a Modern aesthetic to portray the history of Croatian culture in America, while simultaneously addressing the culture of the world at large in its treatment not only of Croatians but of all mankind. In these murals Vanka identified as fundamental immigrant experiences the war that drove him from his homeland and the industry that was subjugating his countrymen in America as similar struggles for power.

From April 9, Vanka routinely worked six days a week, from nine in the morning to two the following morning to complete the murals in time for the church's rededication on June 10, 1937. At that rate it is estimated that he completed a mural every four to five days.[26] He mixed many of his own pigments for the tempera murals on wet plaster, and working in sections, he did not see the complete compositions until the scaffolding was removed. "It is strange how lucky I have been. All those huge figures, and I never saw one of them whole," said Vanka. "I'd paint one part, and change the scaffold. And again I changed it. All were painted in three levels — but they are right."[27] He eschewed any personal contact with family and friends during this period, although he occasionally wrote humorously illustrated letters to his wife and daughter, for he knew that this work would either be the making of his career or its demise, and he did not want to be distracted. He did have a persistent belief that he was visited by a ghost during the murals' preparation, and it was this supernatural visitor that forced him to finish every evening. He took to wearing newspaper "blinders" on the side of his head, and stuffing his ears with cotton so he would not be disturbed by this unearthly presence. Never one to eat much, he ate even less in the feverish pace of completing the murals, which may or may not account for this "hallucination."[28] The legend of the ghost continues to survive in the oral tradition of the church, and while the story sometimes overshadows Vanka's considerable accomplishments, it illustrates the power and significance of the murals and their creation in the community.

Vanka's perseverance was rewarded at the church's rededication, when the community of Croatian immigrants loudly and tearfully expressed their gratitude to him. This heartfelt response was followed by favorable reviews in newspapers and magazines across the country including *Time* and *Newsweek,* which heralded Vanka's work as a renaissance of church art. Vanka had turned an obscure church in a sad industrial town into an icon of religious and contemporary art.

In May 1941, Vanka and Margaret decided to leave Manhattan for the more tranquil surroundings of a farm in Rushland, Bucks County, Pennsylvania. World War II weighed heavy on Vanka's mind. Despite his faith in his fellowman, he was repulsed by atrocities in his native Croatia and throughout Europe. In an interview before he left New York, he reflected on his American experience and the world he had left behind, " I really love this country; I could not be happy in my country under those conditions in Europe. I became a citizen in December — one of the biggest Christmas gifts. The irresponsibility of Hitler must be stopped. This is the great struggle that comes before something better.

Here in America is the development of liberty. You have not the Gestapo. It is open. Democracy has built such nice people."[29]

Despite the Depression, Vanka retained a sense of optimism and hope in mankind. Economic upheaval was not nearly as threatening when compared to the death and destruction of war, which he saw every day, not on the battlefield, but in newspapers, magazines, newsreels, and in letters from friends still in Europe. His friendship with Louis Adamic was also a source of the latest information regarding the war both in Europe and America, as Adamic traveled back and forth between continents while writing books and editing liberal magazines.

Soon after Vanka arrived in Rushland, Father Zagar asked him to return to Millvale and create another series of murals. "My walls have claimed me,"[30] said Vanka, and he was convinced that "every inch of the church must be painted."[31] That summer, when he arrived at the St. Nicholas Church, his thoughts were almost entirely on the war. In his 1937 cycle, only two of the eleven panels carried overt political and social messages outside of the conventional iconography, with subtler messages scattered throughout. His second cycle, in 1941, is primarily of didactic works regarding current events. Vanka's 1941 murals serve as propaganda, seeking to persuade not through heroic or soothing images, but through fear. Even the more traditional iconography of St. Francis, St. Clare, and scenes from the Old and New Testaments are filled with fiery images that speak to the anxiety Vanka must have felt about the war at the time. While he had recognized that "my painting is full of tragedy," it was never more so than when he painted these eleven murals. For these murals he drew equally from the Byzantine and Mannerist traditions. Mannerism favors an intellectual approach to a subject rather than a religious one. Like El Greco and Michelangelo, two of the greatest Mannerist painters, Vanka used elongation of his figures and *horror vaci* (dread of unfilled spaces) to convey his deeply personal and spiritual vision.

On the arched right wall of the church, Vanka painted a scene from the Old Testament of Moses, at the instruction of the hand of God, breaking the tablet of the Ten Commandments while the people worship the Golden Calf. The only commandment on the tablets is in Croatian: "Thou Shalt Not Kill." "On Moses' face is a furious expression," said Vanka, "because the people kill each other for gold." To Moses' right is his brother Aaron, who directs a stroke of lightning to destroy the Golden Calf as well as "the sword of war." Again, beneath this scene Vanka returns to the Mother image for *Mati 1941,* which shows a 15-feet-high figure of a Croatian mother, chained to the cross. Her feet touch an open book on which Vanka wrote a dedication to Louis Adamic, "who wrote so much about the country of Yugoslavia. The figure of an enchained mother shows the suffering of the Christian mother of 1941, but symbolically represents the oppressed countries of Europe, acquired by the Gestapo and submitted by brute force. The mother is enchained and crucified, because for one assassinated soldier they now kill hundreds. At her feet is a destroyed church and town, and a jail, all bloody, to show the cruelty. Hands are reaching through the bars of the jail, asking for help from the mother country, but she can do nothing." Even in this grim scene Vanka sees the pos-

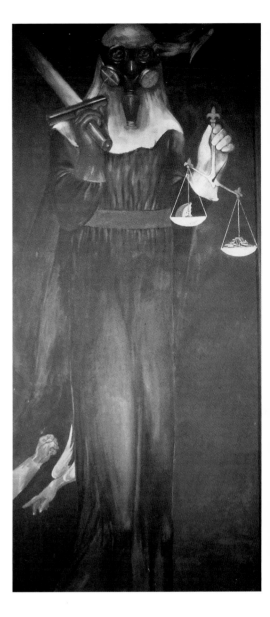

Injustice
Mural for the St. Nicholas Croatian Catholic Church
Egg tempera on plaster, 1941

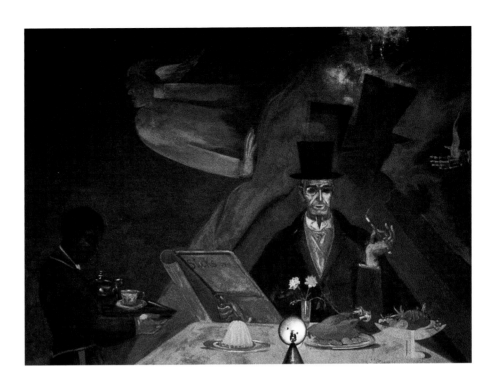

Right, detail of *The Capitalist*
Mural for the St. Nicholas Croatian
Catholic Church
Egg tempera on plaster, 1941

sibility of renewal. He places a linden tree, a symbol for Croatia, at the bottom. Broken — but sprouting a new branch to symbolize hope.[32]

Just as dramatic is the figure of *Injustice*, which Vanka placed below a scene from the New Testament. The chilling figure wears a gas mask, and holds a sword in one hand and a scale in the other. The scale shows gold coins, representing materialism, heavier than a piece of bread for idealism. Greed, along with war, are the primary targets of many of the 1941 murals, for Vanka felt the two were intertwined. Above the sanctuary entrances he painted contrasting scenes of *The Capitalist* and *The Croatian Family*. *The Capitalist* shows the top-hatted title character, painted in dark tones, alone at the head of a table laden with rich foods. He reads a paper titled "Stocks 1941." An African-American servant brings more food, while the capitalist only gives crumbs from the table to a starving African-American man, a modern day Lazarus, kneeling at the other end of the table. Directly across from it, in *The Croatian Family*, Vanka painted a simple working family gathered around a table for a meager meal of bread and soup. Arranged against an industrial Allegheny Valley landscape, the family says grace while a figure of Jesus hovers behind them. Vanka included a portrait of his daughter Peggy in this work, as well as the mayor of Millvale at the head of the table. Its warm tone and the presence of Christ bespeak a natural state of grace for the family.

Perhaps the most unsettling images are those under the choir loft. Simply titled *Battlefield*, in separate sections they show Jesus and Mary interjecting themselves into battle to stop the killing of and by soldiers. A bullet-riddled, tear-stained, fearful Jesus, his heart completely exposed, is shown on the cross wearing not a crown of thorns, but a crown of barbed wire. A soldier looks surprised as he realizes that he has just bayoneted Jesus, while another reacts in horror. The green cast of the soldiers' skin was Vanka's memory of the color of dead men's skin that he saw in World War I. In the other half, Mary (the Mother yet again) interposes herself onto the battlefield, grabbing one sol-

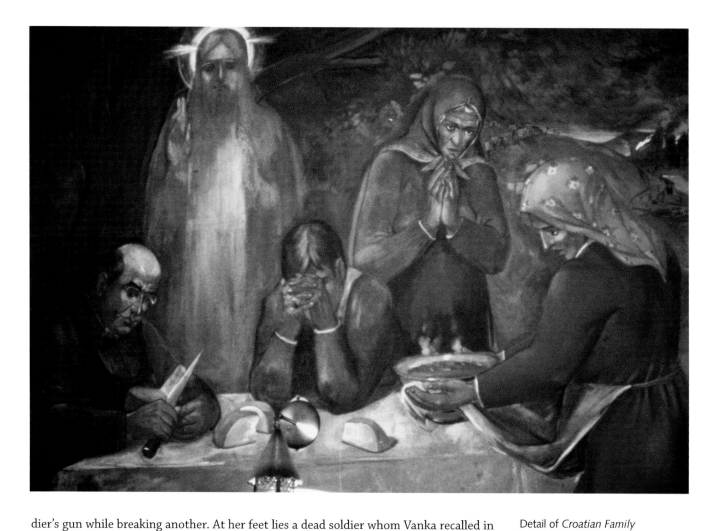

dier's gun while breaking another. At her feet lies a dead soldier whom Vanka recalled in another memory from World War I. "I was walking in a field in Belgium on a beautiful day in May, and I saw a soldier lying down, looking up at the sky. I stopped and said to him. 'Good morning. So you too are a lover of clouds!' He neither answered nor moved, and I saw that he was dead." [33] It is unknown how much preparation time Vanka had for the second cycle of murals. There are no sketchbooks of the compositions as there are with the first set, and no correspondence to give any idea how long the ideas for the work percolated in his mind. He did paint two significant studies for the *Battlefield* mural before he left for Pittsburgh. These works, painted in New York, along with pencil studies of the same compositions, reveal in their original conception that the central figures were simplified, while the backgrounds were more complex. Despite their minor differences, the works resonate with much of the compositional power of the murals.

Vanka began the second set of murals on July 3 and he completed them in the first week of November 1941. Again he worked alone, with a local artisan assisting in the latticework decoration between the mural panels. And again, the murals' completion was greeted with gratitude from the local community as well as with praise in the national press. In an interview upon their completion, Vanka was quoted, saying, "These murals are my contribution to America — not only mine, but my immigrant people's, who also are grateful, like me, that they are not in the slaughter in Europe." [34] For Vanka, their mes-

Detail of *Croatian Family*
Mural for the St. Nicholas Croatian
Catholic Church
Egg tempera on plaster, 1941

sage was simple: "Everywhere they tell men that they must kill. Men must revolt against must-killing." He described the murals in their entirety: "Divinity became human so that humanity might become divine."[35]

Vanka credited Father Zagar with the foresight to give him the freedom to paint his own vision. "Father Zagar is only one priest in a hundred thousand who is courageous enough to break with tradition, to have his church decorated with pictures of modern social significance."[36] Zagar knew the murals would be controversial but he defended them: "It's religion, expressed in our social life. At the same time, it's completely Catholic."[37] Vanka realized, though, that "over in the old country, you could not create a symbolic painting of war as I have done here. It would be impossible to use it for any public building. You are not allowed to do so because it would open the eyes of the people against war. Over there, you must praise war."[38]

In less than one month after Vanka finished this monumental work, America entered World War II after the attack on Pearl Harbor. Vanka continued to be repulsed by the death and destruction of war, yet his work would never again be filled with the intensity of the anti-war sentiment found in the second cycle of murals. In a sense, the second set of murals are a coda to his immigrant experience in America. No longer awed by the technological progress of a new world, he returned to the bucolic landscapes of his childhood. Now he was a naturalized citizen, and America, and more specifically Bucks County, Pennsylvania, was his home.

Detail of *Croatian Family* mural showing Vanka's daughter Peggy

Vanka painting *Battlefield* mural, 1941

In 1981, the Pittsburgh History and Landmarks Foundation, for the first time, created a special category in order to recognize and protect Vanka's murals. In 1982, the church and the murals were placed on the National Register of Historic Places. In 1990, a non-profit organization, The Society for the Preservation of the Murals of St. Nicholas, Millvale, was formed to continue to protect and restore the murals. To support their efforts contact:

The Society for the Preservation of the Murals of St. Nicholas, Millvale
30 Maryland Avenue
Pittsburgh, PA 15209
412-821-1710

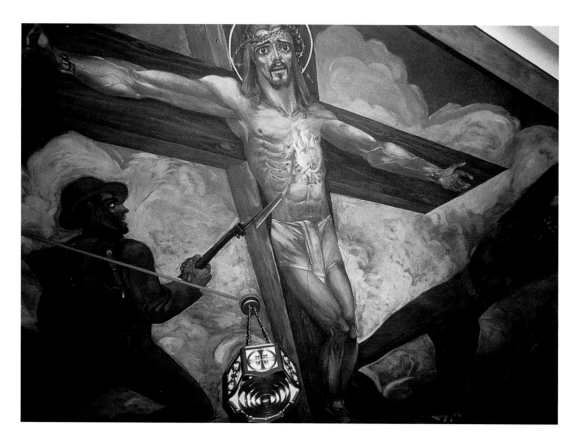

Above, *Battlefield (Christ)*
Mural for the St. Nicholas Croatian
Catholic Church
Egg tempera on plaster, 1937

Right, *Battlefield (Christ)*
Oil on canvas, 22 X 27 in., c. 1941
Private Collection

Opposite above,
Battlefield (Holy Mother)
Mural for the St. Nicholas Croatian
Catholic Church
Egg tempera on plaster, 1937

Opposite below,
Battlefield (Holy Mother)
Oil on canvas, 22 X 27 in., c. 1941
Private Collection

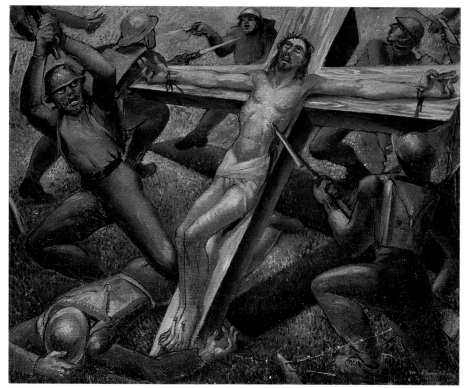

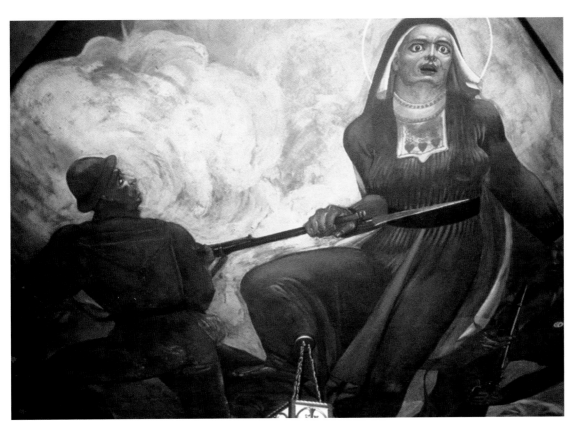

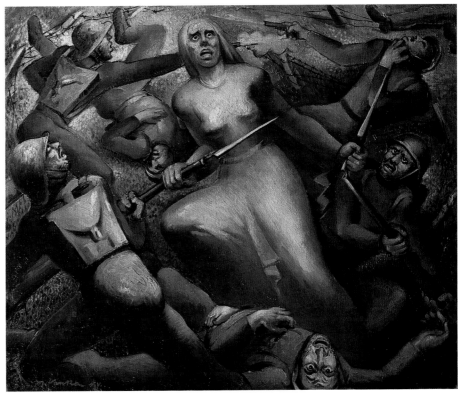

38

At Peace

Bucks County and International Travels 1941–1963
By David Leopold

It is not that surprising that Maxo Vanka would turn to Surrealism, an art born of mistrust of reason and logic, as the world around him sank into war. While there had always been a sense of the fantastic in his work, beginning in 1941 it found expression in his art in a figurative, probably dream-inspired style much like Surrealism's most well-known advocate, Salvador Dali. These works drew on Vanka's academic background, rendering the images in a detailed, almost hyper-realistic manner, rather than the abstract. He was certainly aware of Dali's work while in New York, as reviews of Dali's controversial window display at Bonwit Teller's ran alongside those of his 1939 exhibition at the Newhouse Galleries.[41] He may have seen Dali's "Dream of Venus" pavilion at the World's Fair or the Dali retrospective at the Museum of Modern Art, which inspired many artists as they tried to understand the chaos of a world at war.

While much of Vanka's output after 1941 is undated, we can date at least one work, *The Green Baize Table,* as post–1945, since it includes an image that had gained wide currency after the United States detonated two atomic bombs over Japan to end World War II: the mushroom cloud. Here Vanka uses a crisp, symbolic style to highlight the cruelties of war: an ominous warning against humanity's helplessness in the face of manmade destruction. He shows a globe surrounded by a snake, which also is entwined around a hand holding a few strands of wheat. To the lower left, Vanka returns to the imagery of war that he knew: World War I, the green table, where peace talks were held during the war, surrounded by soldiers in gas masks. Although he shows a broken linden tree again with new sprouts symbolizing hope, Vanka, through the image of a crucifix and the mushroom cloud, intimates that although mankind was once capable of killing one man at a time, and then whole cities, it now had the potential to destroy the world. For Vanka, the atomic bomb must have represented the worst of his fears.

Perhaps it was Vanka's understanding of the basic fragility of life in the atomic age that led him to turn his attention not to the world's problems, but to the simple beauty that lay outside his window. He may have given up on the idea of collective improvement for personal happiness, for all indications are that in Bucks County after the war, until his death, he found a relative tranquillity in his surroundings, and with family and

[Children's Garden]
Oil on board, 30 X 25 in., c. 1959
John and Marya Halderman

friends. He also seems to have sublimated his concern and emotion for the world around him into an emotionally charged palette and brush style in his works.

In many ways, whether he was conscious of it or not, Vanka had succeeded in re-creating his life in Croatia on his arrival in Bucks County. White Bridge Farm was nestled in the gentle rolling hills of Rushland, Pennsylvania, reminiscent of the landscape of his youth in Hrvatsko Zagorje. He was surrounded by fields and meadows, and was close to the headwaters of the Neshaminy Creek, where he could see wetlands and aquatic life. His regular walks through the countryside brought him into contact with a great deal of wildlife, much of which responded to his "gift of sympathy." "Vanka was full of simple-hearted enthusiasm for life and all things living," said Slavic writer Stoyan Pribichevich. "Of a sunny nature, not only did he make friends everywhere, but birds and wild little animals felt singularly attracted to him." [42] Out of his pocket would frequently fly a bird; butterflies landed on his beard. A sparrow that he had rescued became a pet, and Vanka taught it tricks such as "playing dead," landing on his head, eating from his pocket, and waking him in the morning by gently pecking at his ear.

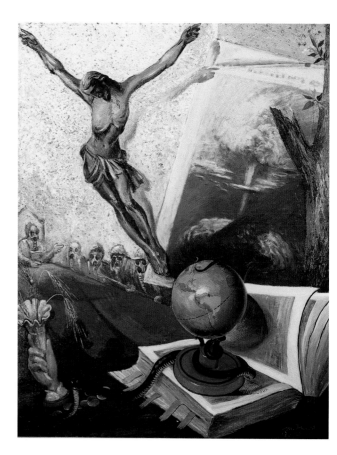

The Vankas had found a venerable old home which they set out to restore. Vanka reassembled his living room from Zagreb in his new home with furniture he had brought over in 1938. He painted the walls of his dining room with demure murals of the Four Seasons, much like those in his summer home in Korcula. He turned the barn into his studio, while Margaret turned their home into a comfortable place to entertain and relax. Unwittingly Vanka had joined a migration of artists to the Bucks County area that began in 1898 with the arrival of Tonalist painter William Lathrop and Impressionist Edward Redfield. There was a well-established colony of artists along the Delaware River, with its center the New Hope, Pennsylvania–Lambertville, New Jersey nexus, as well as a number of artists scattered throughout the countryside. Artists were attracted to the cool gray light of the area and the verdant landscape dotted with historic structures that dated to the nation's founding. Its proximity to Philadelphia

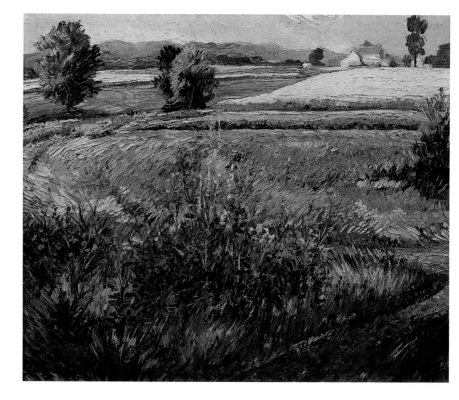

Left, *The Green Baize Table*
Oil on canvas, 37 ¼ X 30 in.,
c. 1945
Private Collection

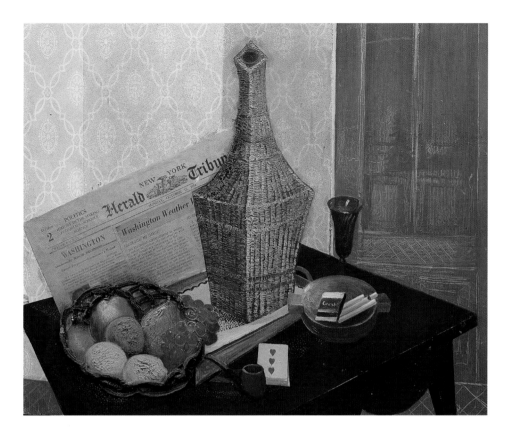

Right,
[Still Life With Fruit, Pipe And Newspaper]
Mixed media on board,
20 X 24 ¼ in., 1954
Private Collection

Left,
[View From The Studio, Hollyhocks In Foreground]
Oil on board, 20 X 24 in., c. 1942
Private Collection

and New York was an added bonus for those who could not afford to be too far away from "civilization." There were groups of Impressionist and Modernist painters in the area, but it was not in Vanka's nature to join any particular group. The arts were held in high esteem in this rural enclave, so it was an ideal setting for Vanka.

In the years after World War II, Dr. James Work, president of the National Agricultural College, knew that in order to attract GIs to the school in Doylestown, Pennsylvania, he would have to offer more than agricultural courses. He wanted to inject liberal arts into the curriculum, so in 1947 he approached Vanka, a nearby neighbor, to teach an art appreciation course. Work recognized that Vanka was a painter rooted in a classical tradition, whose natural inclinations would give him empathy for his students. Vanka joined the faculty on the condition that he would teach his art appreciation course as a studio workshop, where students would learn by painting and drawing. The return to teaching reminded Vanka of his years as a professor of painting at the Academy of Beaux Arts in Zagreb. Vanka enjoyed teaching eager students, and he quickly became a favorite. After class Vanka and his students would head to Ed's Diner in Doylestown, where gatherings often went into the night. "It always reminded me of the great universities in France, Germany and other countries," remembered newspaper columnist Lester Trauch, "where students hang on every word and the philosophy and teaching of their favorite professor." [43]

Vanka believed that there was more to art than looking at a painting in a museum. He felt "that a people cannot grow without culture," according to friend and writer Hazel Gover, "and a true culture can be acquired only when it is woven with skilled hands into the fabric of its youth." [44] At the end of his eight-year tenure as a professor, his students

dedicated their yearbook to Vanka: "A man whose influence upon us, for our betterment, will not end with graduation...More than his art to us is the beautiful philosophy he expresses. He finds beauty in all life situations. He is a man who makes living an art." [45]

It was the Bucks County landscape that attracted Vanka, a fertile setting that had inspired generations of painters. While many of the region's artists captured a bucolic paradise in a number of lush paintings, Vanka re-imagined the landscape as one filled with emotion. In these richly impastoed paintings, his drawing became simpler and clearer — the brush style dominated by gesture, the color roughly applied in simple masses in his compositions. "I am Impressionist," said Vanka in a 1962 interview, when asked about his work. "My ideals are Van Gogh, El Greco. They are beautiful." [46] The precedents in Vanka's work in Bucks County can be found in both artists. As in Van Gogh's work, Vanka's paintings and drawings have an instinctive, spontaneous quality. Vanka also shared with Van Gogh a near-preoccupation with sunflowers in his later still lifes. And with El Greco, he shares an intense personal vision rooted in deep spirituality. The intensity of all three came from the strongly felt need to paint.

His reaction to his work was curious. He had one small show in Bucks County in 1949[47] and then stopped exhibiting his work altogether, believing "my kind of art is no longer fashionable." [48] His statement belied the scope of his work at this time. A number of his still lifes forsake pictorial illusionism in favor of the two-dimensionality of the picture plane. He produced a number of oils such as *Still Life with Fruit, Pipe and Newspaper*, in which he flattened his subject matter, and he even collaged items such as newspaper headlines and pieces of basket, while using bright, high-keyed color. These contemporary techniques mirrored the latest developments in representational work around the world.

Below, *Mexico*
Pastel, 10 ¼ X 14 ½ in.
Private Collection

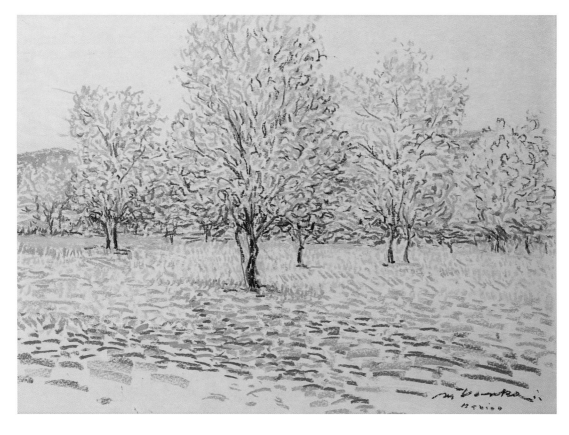

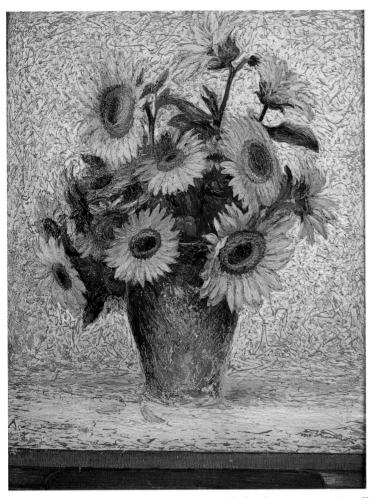

Sunflowers
Oil on board, 33 ½ X 26 in.
Private Collection

In another painting, *Sunflowers,* Vanka turns the background of his Post-Impressionist still life into an action painting, with drips and swirls dancing behind the central subject. He continued to address social conditions in a number of paintings, albeit not on the large canvas of the Millvale Murals. He used the latest materials in his metal sculpture, creating a series of typically elongated stylized figures. Like many of his generation, his art was representational at a time of the rise of Abstraction, and therefore he felt it was a bit old-fashioned. Vanka was interested in the latest trends in art, and even experimented with a few, but he did not feel they could express his feelings. "Abstract art can be beautiful," he said, "like music, with all its colors. But it is a wall. Where do you go from there? How do you control it? Art must relate to nature. It must be true to human form. Abstract art is a dead end."[49]

In 1955 Vanka and his wife left for a ten-month excursion through Asia, North Africa, and Europe. He sent a series of postcards with pastel landscapes to Margaret's stepmother, all with running commentary of their journey and instructions not to throw the cards away. In almost every city and village that they visited, Vanka wandered off to record his impression of the place in numerous pastel drawings and to meet people. The drawings are mostly landscapes, occasionally incorporating elements of local architecture. Upon his return to Rushland, he used the illustrated postcards, along with his sketchbooks, to assist him as he painted the last major works of his career.

Vanka increasingly turned to pastel for his compositions. He may have enjoyed the immediacy, the ability to capture the fleeting moment. In his pastels, particularly the landscapes, his drawing became even more stylized. Almost everything in his drawings seems to be moving; and in the landscapes, growing. His mature style is calligraphic, with simple bold strokes delineating his subjects. In the pastel drawing *Mexico,* Vanka drew the trees in quick gestures that echo Van Gogh as well as a contemporary painter of Vanka's time, Matisse. The ground is made of brief lines of pastel that undulate beneath and around the trees. These strokes, repeated throughout the drawing, make the work shimmer with vitality.

It would be difficult to separate the emotion from the technique in these works. Vanka's art was an expression of his philosophy, and as such, his view of the world is accurately reflected in his later paintings and drawings. He viewed the woods, around his home and wherever he traveled, and their inhabitants, with constant wonder and reverence. Flora and fauna excited and inspired him. He was a deeply spiritual man, but he rejected the dogma of the church. His sanctuary was in nature, among the trees, birds, and plants.

The paintings from his round-the-world trip are not the serene vistas seen in his pastel drawings, but complex studies of life and the human condition. For Vanka, these works reflect the climax of his views on life and death. Perhaps the most compelling work from this series is *The Leper Colony*. In this massive allegorical canvas, Vanka unflinchingly shows the members of the colony he visited, all female, as they struggle to survive. The central figure is missing limbs and facial appendages, and displays a hollow, deathmask face. She is approached on the left by a weary young traveler, a man with an animal-skin sack on his back and with his left arm, cup in hand, outstretched, evoking the image of the *Crippled War Veteran* from two decades earlier. Is he asking for something? If so, Vanka's women have nothing more to give. The strong Mothers of Vanka's imagination, even one with a child on the right surrounded by a halo of sunlight, are literally falling apart. Mangy dogs scavenge on the right side of the canvas for bones, perhaps of previous members of the community, while behind the figures rises an ominous industrial mountain, crowned by a crowded city, seemingly unaware or uncaring for the unfortunates below. In this sobering work, even the broken trees have no sprouts or blossoms to offer hope. As if to reinforce in his mind the demise of his long-cherished women, Vanka painted *The Leper Colony* on the verso of the epic canvas of *Nase Majke* from his Croatian days, and signature work from the Millvale Murals.

In 1957, Vanka's friends finally prevailed upon him to show his work in New York once again. He showed a number of his large allegorical canvases alongside his more traditional still lifes and landscapes. While the pastel drawings from his world travels garnered some praise, a review in *Arts* magazine summed up the response to the more challenging work. "On the fantastic side, *The Four Horsemen of the Apocalypse,* an imitation of Blake in greens, yellows and blues so raw they rival the falseness of the pose, and *Life and Death,* where industrial forms rise to a central peak, blatantly sexual, and where the theme between age and youth, the young man and the old, is played out with arrows, indicate the range of this artist is pretty far beyond the appreciation of our American taste." [50]

Although he would never exhibit again in New York, he continued to have intimate exhibitions in the Bucks County area. He continued to explore metal sculpture, interpreting religious and mythical figures in his own personal style, even returning to the Johnstown mining disaster in *The Accident,* a study of two men helping a fallen comrade. He also continued to draw on Croatian culture in his work and in his family. In the painting *Children's Garden,* he shows a miniature Croatian church he constructed for his grandchildren in the garden where he could often be found when he was not in his studio. He remained active in the community with sketching classes in his studio. Every winter the Vankas set off for Mexico to paint.

At the close of an exhibition in December 1962, the Vankas left Bucks County for Mexico for the winter. On the afternoon of February 2, 1963, Vanka told his wife he was going for a swim in the waters off Puerto Vallarta and would be back for dinner. He would never return. It appears likely that the seventy-three-year-old artist had a heart attack while in the water and drowned. His body washed ashore the following day. It was a sudden close to a life of passion, paradox, and prodigious accomplishment.

Right,
Nase Majke (Our Mother)
1914 – 1918/Leper Colony
Oil on canvas, 54 X 72 ½,
c. 1918/c. 1956
James A. Michener Art Museum
Michener Art Museum Endowment
Challenge
Gift of Margaret Vanka Brasko

Although he had the resources for more canvas, Vanka utilized both sides of one canvas for these epic works. The original side, *Nase Majke (Our Mother) 1914 –1918,* was cut down and restretched almost forty years later for the important late work, *The Leper Colony.*

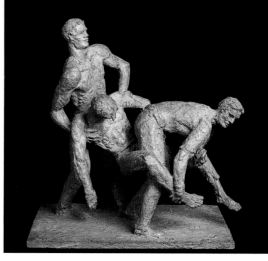

The Accident
Sculptmetal, 9 X 14 X 15 in.,
Private Collection

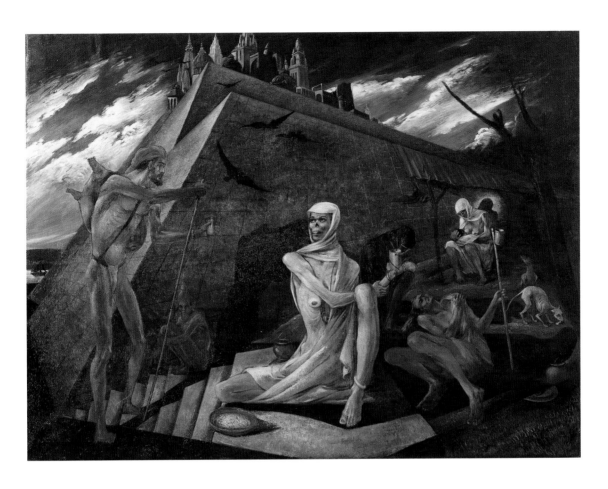

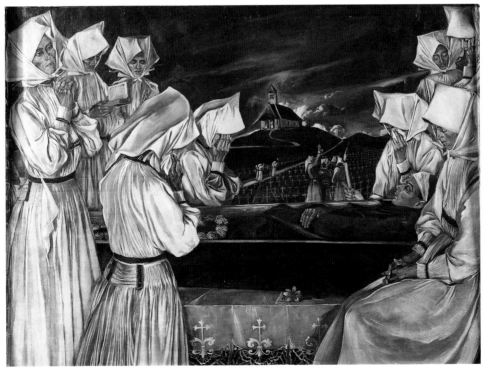

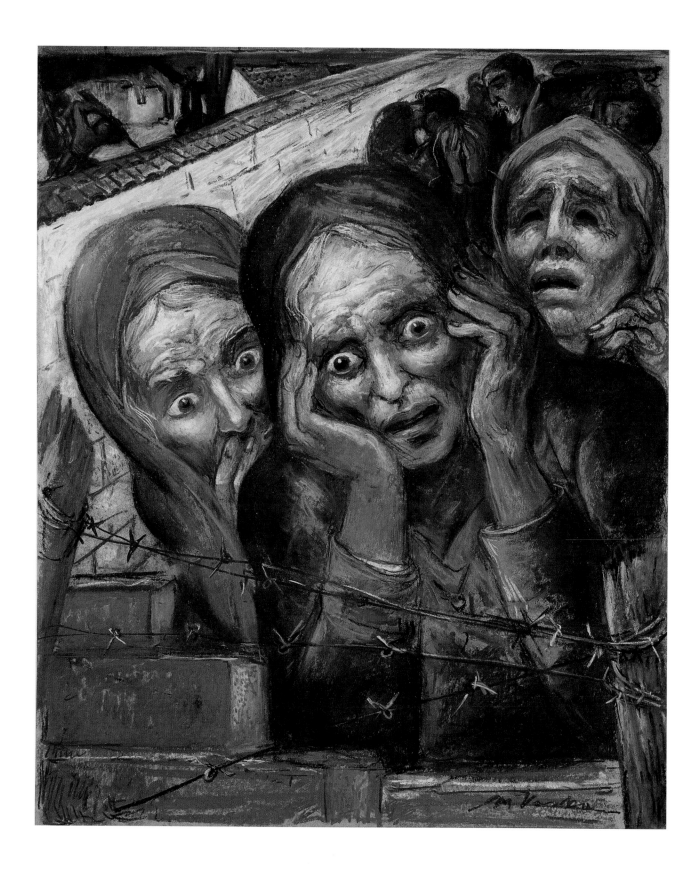

Epilogue

In the aftermath of Vanka's death, Margaret returned to Bucks County with Vanka's ashes, which were later scattered over the lower Potomac in an airplane to be borne out to sea. Always her husband's tireless supporter, and now keeper of the flame, she arranged for a memorial exhibition of his work at the Scofield Gallery in Bucks County. Without a funeral, the exhibition allowed people in the region the opportunity to pay tribute to Vanka's life and work. Artist Alden Wicks was quoted in a local newspaper as saying, "Knowing full well that we would miss him [he] left these bright fragments of

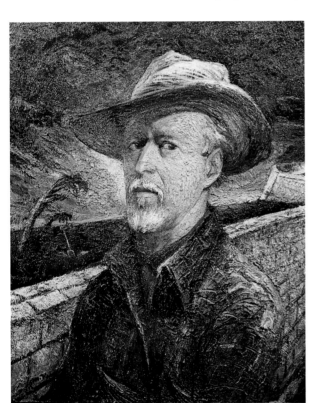

Self Portrait
Oil on board, 24 X 20 in.
Private Collection

himself to make us glad we knew him."[51] Recognizing his "gift of sympathy" for birds, a sanctuary for injured birds was established in his name at the Washington Crossing Education Center in Pennsylvania. Margaret offered *The Green Baize Table* to the New Hope Historical Society, but they felt the work was too controversial for their collection.

In 1968, Margaret, and her stepmother, Alice Stetten, working with the government of Yugoslavia, established a museum of Vanka's work in their former summer homes on the island of Korcula. They also endowed it with funds to establish an arts colony similar to the famed McDowell Colony in New Hampshire. The museum was closed for six years during Croatia's fight for independence and reopened in 1998.

In 1975, Vanka's daughter Peggy and her husband Alexander Brasko retired to White Bridge Farm to be with Margaret, who maintained an active social life and continued to visit Mexico and Haiti during the winter months, until her death in 1997. In 1981, David Demarest, a professor at Carnegie Mellon University, wrote and produced, along with Pittsburgh's traveling theater troupe The Iron Clad Agreement, *Gift to America,* a play about the creation of the Millvale Murals, which was performed at the St. Nicholas Church. In 1990, members of the church formed The Society for the Preservation of the Murals to protect and restore the murals.

Vanka's work is still highly regarded in Croatia, which has mounted a number of exhibitions of his work in the last ten years. In 2002 a major retrospective of his career will be mounted at the Klovicevi Dvori Museum in Zagreb.

Rebecca West may never have known Vanka, but her extensive travels in Croatia revealed the essential nature of his countrymen, especially in relation to other countries in Europe and America. In writing about them in *Black Lamb and Grey Falcon,* she could have been writing about Vanka.

"Here was the authentic voice of the Slav. These people hold that the way to make life better is to add good things to it, whereas in the West we hold that the way to make life better is to take bad things away from it."

Left,
Anguished Figure
Conté, oil, and pastel on paper,
22 X 17 ½ in.
James A. Michener Art Museum
Gift of Margaret Vanka Brasko

David Leopold
Curator

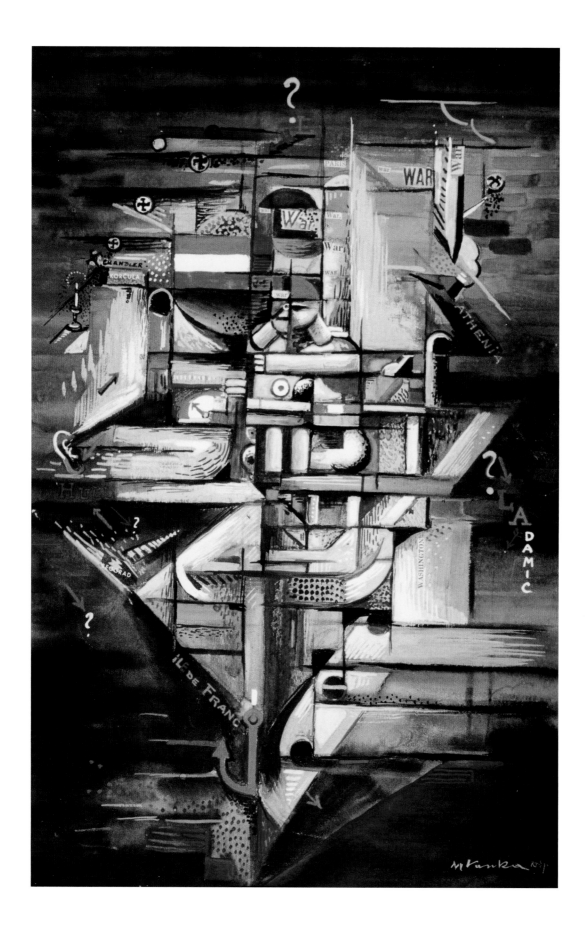

48

Reading a Painting

Excerpt from *Reading a Painting: Maxo Vanka's Collage "World War II"*
by Henry A. Christian and Tine T. Kurent

The primary subject of this study is the only complex collage of the two of such genre Vanka is known to have executed. Coming upon this work in a gallery or museum, the viewer immediately senses a formidable visual and intellectual challenge. The collage offers a palette of bright and subdued watercolors and a myriad of shapes within shapes, of recognizable and possible symbols, of words both obvious and obscure… An attempt to read the collage, Braque-like, may offer a beginning organizing principle. The word "war," cut from newsprint, is pasted in the upper half of the painting ten times. Also cut from pre-printing are the names of the capital cities Beograd (Belgrade), Paris, and Washington. From pre-printing too is the island and/or island town of Korcula added, complete with accent mark; and painted on are the letter "L" and the words "Hull," "Chandler," "Athenia," "L? Adamic," and "Ile de France." Readers of Louis Adamic can quickly link the initial L at what can be called the start of the collage to the author's full name elsewhere and probably know the author-artist friendship from Adamic's books and articles.

"Hull" and "Chandler" are nautical words, meaning structure and a ship dealer or trader, but seem rather inconsequential in the context of the names of two real ships Vanka employed. The *Athenia,* torpedoed on September 3, 1939, is the first ship sunk in World War II and is so shown in the collage, specifically placed below the threatening sword-bomb shape bearing the word "war." [52] The collage therefore could not have been painted before September 4, 1939. Possibly remembered too is the fact that the French liner *Ile de France* arrived at Havre on August 30 and was scheduled to leave for New York on September 1, 1939. But the ship waited in port to take on nearly 400 extra passengers, mostly Americans, and finally sailed on the first day of the war, arriving at New York the night of September 9 and docking the next day. The liner name immediately beside a bright red anchor indicates the collage intends the true ship; the collage therefore post-dates this American port arrival. [53] Notice of the liner also prompts attention to the overall shape of the collage. Reminiscent of the famous A. M. Cassandre 1935 poster of the liner *Normandie,* the ship next to which the *Ile de France* was docked on September 10, the Vanka collage takes on the shape of a ship, although there it would seem a vessel

World War II
Mixed media on paper,
17 X 11 ¼ in., 1941
Private Collection

possibly prow down where the Cassandre rendering is if anything prow up. In evidence as well are two air ventilators and any number of other mechanical shapes and planes that may symbolize the interior of a vessel. Midway on the left are brushstrokes which could be windows or portholes. From Adamic and other sources it is clear Vanka was a unique, highly imaginative, deeply knowledgeable, even somewhat mystic person. Interpreting his vision is therefore an exercise of one's own imagination.

The opening initial "L" with its accompanying question mark may therefore prepare for Adamic but also evoke the memory of the *Lusitania,* the 1915 sinking of which moved the United States closer to entry into the Great War, as the *Athenia* may be doing for this 1939 war. Since war is clearly one theme of the collage, a viewer may ponder the opposing blue and red arrows, often with a question mark nearby. What will the war mean to Louis Adamic and his work, to Washington, to Adamic and Washington, to Belgrade? Furthermore, the ear into which something must pass and then move on to and from Belgrade clearly seems to be linked not to a maritime structure but to the American Secretary of State Cordell Hull (1871–1955). The bold presence of the flag of the Netherlands may indicate the May 10, 1940, invasion of that nation and Belgium and Luxembourg; the collage would certainly be configured differently had these other capitals and nations been more involved, so 1939 seems still a most probable date of composition.

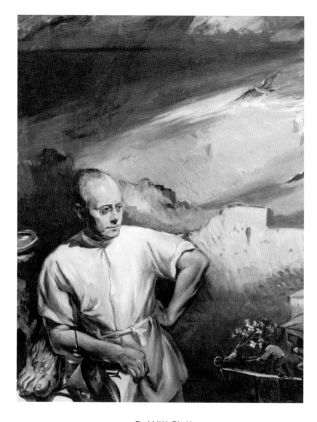

DeWitt Stetten
Oil on wood panel, 17 ¼ x 13 ¾ in.
Private Collection

Yet most provoking and baffling amid possible readings of the collage are the words "Korcula" and "Chandler," and within their relationship lies both the personal and the eventual universal meaning of this work of art...Just to the left of Chandler in the collage stands a form that looks like a Celtic cross, which either changes to or is actually the beginning of the series of circles or perhaps mines which contain proto-swastikas and their accompanying masses of black dots — some of which already fall toward the burning candle — that eventuate in the birdlike droppings just above the sinking *Athenia.* But it is most improbable that Vanka should construct a collage with no more organizing principle than that he wished to note the names of major cities, his good friend Adamic, the site of his summer home, and a good deal more all within the frame of the 1939 war.

Indeed, the origin of the Vanka collage is quite the opposite kind of process. Each summer after moving to the United States, the Vankas and their daughter spent a portion of their vacation on Korcula. Margaret Vanka's father, Dr. DeWitt Stetten, had purchased a house beside the artist's cottage; and the doctor and his second wife Alice usually were in residence with the Vankas. In 1939, only the Stettens made their usual journey abroad. Late in the summer, under war clouds, they made their way from Korcula north to Paris and at Le Havre boarded the *Ile de France* in time to be passengers on that secret, dangerous passage to America. The voyage, the war, the world — these were important matters to the three families, and it is probable that together for Thanksgiving dinner in 1939 the Stettens had the opportunity to recount their summer at length to the Adamics and provoke within Vanka the collage he would soon produce. The *New York Times* account of the

voyage captured some of the excitement the Stettens must have exhibited:

> When they appeared for the usual immigration examination, passengers were informed that the State Department would retain their passports. They received landing cards as usual, and were told that for futures voyages to Europe they would have to reapply for traveling papers. The Americans, glad to be home and away from the continual dread of a periscope sighted at sea, accepted the ruling without protest.
>
> Officers of the ship maintained the usual silence, and passengers told the usual stories of alarms, imagined submarines and wished-for naval escorts that apparently never materialized.[54]

Although one of Vanka's shapes is certainly the French liner, within that form is also that of a threatening submarine. The ventilators are therefore also periscopes; and the partially red helmeted face, evolving from all manner of circle-like bombs emanating from those beginning at Korcula, is at least with one eye openly sighting for some victim. Below that head-face, which seems to have a body or legs of some sort, is the red and white circle like a bull's-eye but reproducing the German national symbol traditionally worn above the visor of both dress and field uniform caps. The mechanical innards of both vessels mesh, the upper portion of the collage being more submarine, the lower more liner. Hidden within is the liner's barely visible, secret national flag. In the upper half, war, the words of sinkings, and danger predominate; the lower half of the form indicates the liner and its name and a safe anchorage finally achieved. What at the top had been bomb-like circles may even by the bottom have become musical notes of greeting.[55]

Yet once the crossing had been explained, the Stettens had still more to impart. On Korcula they had encountered an American writer, Douglas Chandler, who had written articles in the *National Geographic,* including one titled "Changing Berlin" and another about Yugoslavia titled "Kaleidoscopic Land of Europe's Youngest King."[56] At the conclusion of that article, Chandler had written: "Then, one bright day, passing a house in Korcula town, an ancient house from the top story of which ran a covered bridge to a fifteenth-century tower, someone whispered in my ear, 'That house can be bought.' I hesitated, and was lost."[57] In the close confines of the island, the Stettens therefore found Chandler that summer living well and enjoying something of celebrity status. Appalled by Chandler's open profession of pro-Nazi, anti-Semitic views, the Stettens saw the American writer as both a threat to the tranquillity of Korcula and a catalyst for the Fascist aura pervading Europe. Safe at home by September, the Stettens had lost none of their anger toward Chandler. Dr. Stetten had fired off a letter to the State Department: Would Secretary Hull take notice? Would Washington contact Belgrade about the American Nazi? Could Louis Adamic, who was perhaps aware of Chandler's articles if not his politics, employ some of his Washington contacts about Chandler?

As the situation unfolded before Vanka, the artist could only be extremely intent. In *My America,* Adamic had written that Margaret Vanka "believed I had helped her in getting [Maxo] to decide to come to America. What had, I think, really decided him just then was his thought that he had no right to keep his wife and child in Europe where the dangers of war seemed to be increasing by leaps and bounds."[58] What Adamic was too self-effacing to say was that Vanka had acted on advice Adamic had given him in the winter of 1933. In Zagreb, waiting in line to see *City Lights* one night, Adamic had pointed out to Vanka that the Nazis had no interest in honest writing, good art, or their own respective spouses, both of whom were Jewish. Now, in 1939, here was Douglas Chandler spewing anti-Jewish hate amid the purity, the honest light of hope of Vanka's ideal,

ancient Korcula, spreading the kind of horror that had already sent much of Europe to war. With what may be imagined as determined intensity, shortly afterward Vanka set to work on the collage, executing it on what is the large, seamless side of an ordinary grocery store paper bag. When he had finished, the artist gave the work to his friend Adamic.

"The Beginnings of World War II," a sufficiently appropriate possible title for the collage, obviously carries great significance within Vanka's life and body of works, both known and only now being brought to light. It draws nearly as much attention in Adamic's history as well. Methods in the collage presage some of Vanka's anti-war forms when he returned in 1941 to the St. Nicholas Church. In his frightening, full-length rendering *Injustice,* a figure bearing a bloody sword balances gold coins as more valuable than bread and wears a gas mask. The questioning, opposing arrows of Vanka's collage are now altered to two joined, winged hands, one attempting to pull at the eye piece of the gas mask while the other points away, a forefinger directed upward to the Madonna *Mary, Queen of Croatians* above the altar. Opposite *Injustice* Vanka painted *Mother 1941,* a full-length crucified female figure at whose feet lies an open book which contains the words "Mati 1941, To Louis Adamic."[59]

Louis Adamic, 1944

Important as the collage may be for those interested in Vanka and Adamic, the work of art has significance beyond either man or the causes of its inception. Much as Picasso's *Guernica* is always a commissioned depiction of the 1937 bombing of a Spanish town, the painting nevertheless is forever perceived in light of the subsequent defeat of the Spanish Republicans and the coming of World War II. So too does the final importance of Vanka's collage depend on later events. Dr. Stetten's letter of complaint was sufficiently heard in Washington to cause the Yugoslav authorities in Belgrade to revoke Chandler's residence permit in August of 1940. Told to leave Korcula before September 1, Chandler then settled in Florence.[60] On May 27, 1941, the *New York Times* carried the following item under the title "Reich 'Paul Revere' Reveals Name":

> One of Germany's radio commentators for America, "Paul Revere," disclosed his identity last night in his regular broadcast over the official German radio, the National Broadcasting Company reported. He said he was Douglas Chandler, and that he was celebrating his fifty-second birthday. He declared that he was known in advertising and journalistic circles in the United States and had worked from 1936–1940 on the *Baltimore American* and had been a feature writer for the *National Geographic Magazine.*[61]

Two years later Chandler was again in the *Times,* now with Ezra Pound and six others indicted for treason for "broadcasting Axis propaganda for Germany and Italy."[62] Attorney General Francis Biddle noted, "It should be clearly understood that these indictments are based not only on the content of propaganda statements, the lies and falsifications which were uttered, but also on the simple fact that these people have freely elected, at a time when their country is at war, to devote their services to the cause of the enemies of the United States."[63] In a breakdown of the eight accused traitors, material from the Department of Justice files reported Chandler's various employments and publishing ventures. "By 1938," the *Times* noted, "his conversion to Nazism was 'complete' and he extolled its virtues in lectures in England and Scotland. In 1940 his anti-Semitic and pro-Axis views forced the Yugoslavian Government to withdraw his temporary residence permit."[64]...By September 20, 1945, Chandler was listed as one of five of the traitors